Westlands

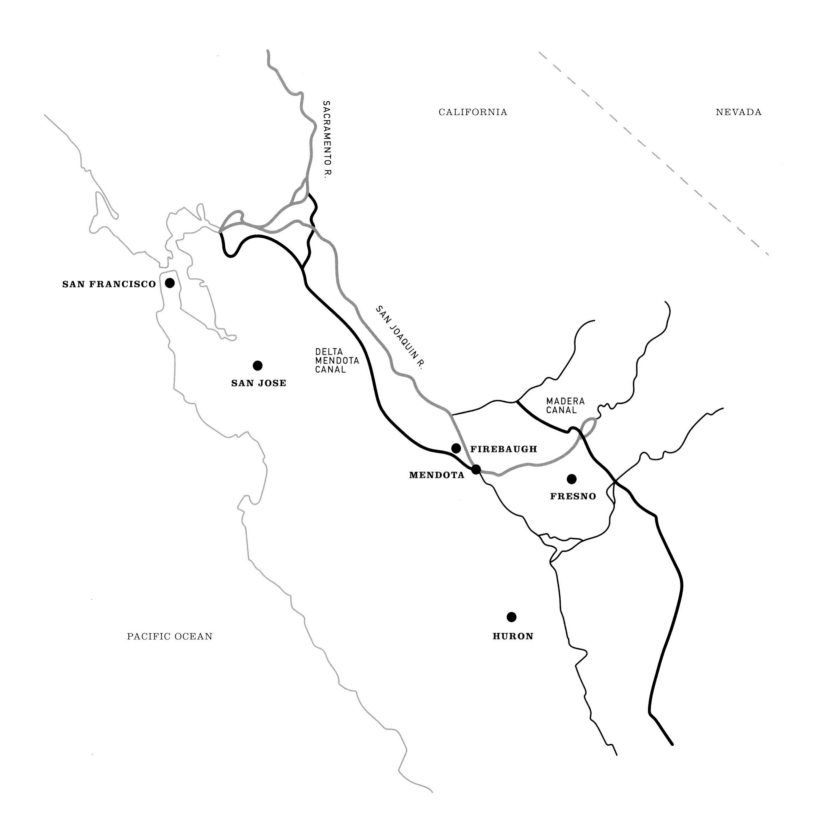

CALIFORNIA

NEVADA

SACRAMENTO R.

SAN FRANCISCO

SAN JOSE

DELTA
MENDOTA
CANAL

SAN JOAQUIN R.

MADERA
CANAL

FIREBAUGH

MENDOTA

FRESNO

PACIFIC OCEAN

HURON

WESTLANDS A Water Story

PHOTOGRAPHS	RANDI LYNN BEACH
INTRODUCTION	THOMAS HOLYOKE
ESSAY	YIYUN LI

University of New Mexico Press | Albuquerque

Library of Congress Cataloging-in-Publication Data

Names: Beach, Randi Lynn, 1967– | Holyoke, Thomas T. |
 Li, Yiyun, 1972–
Title: Westlands : a water story / Randi Lynn Beach,
 photographer ; Thomas Holyoke and Yiyun Li,
 contributors.
Other titles: West lands
Description: Albuquerque : University of New Mexico Press,
 2017. | Contains list of photographs.
Identifiers: LCCN 2016044390 | ISBN 9780826358363
 (cloth : alk. paper)
Subjects: LCSH: Water use—California—Pictorial works. |
 Water in agriculture—California—Pictorial works.
Classification: LCC TD225.C264 B43 2017 |
 DDC 333.91009794—dc23
LC record available at https://lccn.loc.gov/2016044390

Cover photograph by Randi Lynn Beach
Designed by Lila Sanchez
Composed in Gotham. Display type is Aller.

Contents

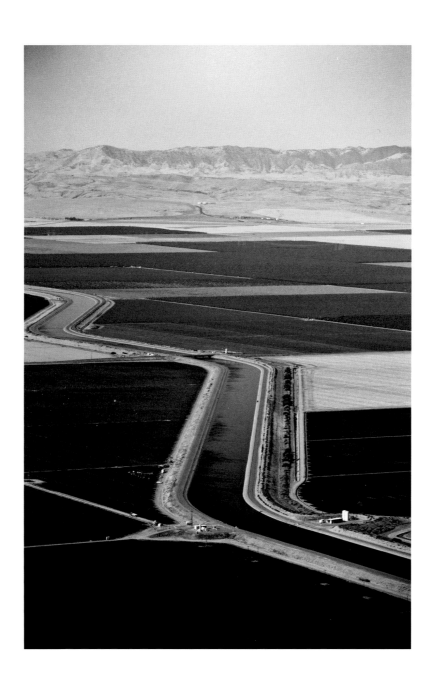

Introduction

Thomas Holyoke

I never thought about where water came from when I was growing up in western Nebraska. I don't think many Great Plains farmers do today, either, judging by the rate at which the vast Ogallala Aquifer is being pumped dry to water the sea of corn that stretches across the prairie. While Nebraska's day of reckoning is yet to come, California's is here, especially for the western side of its great San Joaquin Valley. Worrying about water, though, is not new for farmers growing crops on the dusty plains vaguely referred to as the Westlands. The western valley can be generously described as hot and desolate. Native Americans largely avoided it in summer. So did the Spanish missionaries. Early settlers of European descent used the land for cattle, when they used it at all. A few grim men, lacking alternatives after the gold-rush mirage faded, tried farming it but found the land too dry for growing. Then somebody dug a well and discovered a bonanza of water under the parched earth, and suddenly

vast agricultural enterprises sprung into being. By the 1940s that miracle was over. The groundwater on which these Westlands farmers depended was badly depleted and no alternative was in sight. Cool mountain water flowed out of the Sierra Nevada down the San Joaquin River, but it was already fully claimed by other farmers. Desperately, western valley growers turned to the federal government for help, and the American taxpayer provided them with enormous reservoirs and canals that brought water from hundreds of miles to the north at bargain prices. With this water Westlands farms became some of the nation's most productive and profitable growers, producing vegetables, melons, almonds, pistachios, and countless other crops that were exported all over the world. Yet today, amid one of the worst droughts in California's history, its growers once again face extinction.

Nothing about the Westlands has been without controversy. In the nineteenth century a man would have been thought crazy to farm there. Critics today say that it should never have been farmed at all. The land is incredibly dry, and it is so far from natural water sources that the risk of total disaster always looms. Much of it is so laden with poisonous salts and selenium that nothing can be grown without their removal. A convoluted system of water laws puts many Westlands farmers at the bottom of the allocation priority list. We are often reminded that the government's watering of the western valley, and its growers' subsequent wealth, comes at the taxpayers' expense. Dams, reservoirs, and canals are expensive, and the water delivered is sold so cheaply that the cost of building these systems may never be repaid. Nor,

critics say, has the government ever demanded much of Westlands farmers in return for these public subsidies. By diverting water to help western valley farmers, California's rivers and wetlands are being damaged, decimating the fish and bird species that depend on them for survival. Best, they argue, to let the Westlands revert to dust and scrub grass.

Perhaps the western San Joaquin Valley should never have been farmed, but that decision was made decades ago and it is neither easy nor wise to turn back the clock now. The new American aesthetic may be more about living with nature rather than rearranging it with dams and canals, but before we decide to dry out the Westlands we should realize that undoing the perhaps-foolish decisions of the past may have disastrous consequences for the future. Enemies of the Westlands have forced the government to greatly reduce the water it ships to western valley growers in order to save fish from extinction, but they appear unwilling to admit that this threatens the livelihoods of the people living there. Often they fail to acknowledge that these people exist at all. It is the hopes and fears of these invisible people that are captured here by Randi Beach's photography, just as the essential role water plays in our lives is celebrated in Yiyun Li's essay.

I had no idea what to expect when Randi first called me about her plans to photograph the effects of lost water on the western San Joaquin Valley. Bay Area photographers wanting to do exposés on valley farming and water use usually means hatchet-job caricatures of super-wealthy landowners colluding with spineless lawmakers to exploit cheap migrant labor and taxpayer subsidies.

That story has been told many times—usually with little regard for facts. Randi, however, sought a human story, and she found several. She found immigrant farm laborers fearful of losing work, and thus their ability to support their families, when fields go dry. She found grim farmers forced to sell their grand-parents' land to corporate conglomerates not even based in California. She found gas station owners, grocery store clerks, farm equipment dealers, and restaurant servers all terrified of losing their livelihoods because apparently somebody said fish are more important than they are. She found a people's way of life being sacrificed in a war over water they did not start and often do not understand. Randi makes no apology for the great land barons who once exploited loopholes in California's bizarre water laws to grab water and land on the cheap, and who frequently lived closer to Santa Barbara and San Fernando than their San Joaquin Valley farms. What she does is show how trying to undo the decisions of the past by turning off the water devastates the people of the present, denying them a future. Decisions matter. Randi's photography makes us aware of the human cost when the water goes away.

The Natural History of Water

Yiyun Li

There are museums of natural history, where desiccated bones of prehistoric creatures and plant fossils, preserved without the water that had once been an essential part of them, remind us of our limited longevity. There are museums of ancient cultures, where our predecessors' achievements are on display, and their narratives are in part a story of water: of keeping water with vessels made of stone, wood, bronze, bone, and earth; of finding water in the discoveries of springs and wells; of taming water by building dams and irrigation systems; of creating legends out of water, including the antediluvian tales found in different cultures.

But water itself does not have a prominent history, nor does it offer a museum full of wonder. The most abundant compound on earth, it remains unchanged over billions of years and trapped in a cycle that does not seem to let it go anywhere. Water has always been here, long before we came, and

perhaps—but who can be certain—it will always be here. Water, like air and sunlight and the earth's rotation and love, can so easily be taken for granted. Of course we will wake up to the daylight; of course water is here to quench our thirst.

A while ago I visited Ireland and stayed in a hotel where part of the façade was a waterfall. Even if we were to lose everything in this country, my Irish host said, we would still have water. This, he explained, was why it was a struggle for the European Union to enforce the water fees in Ireland. Why do we have to pay for water, when we don't pay for air?

The belief that water could be inexhaustible pained me, because not long before that, water had seemed absolute in California, too, at least outside of agricultural life: there were days when my children, in preschool then, would spend hours in water play, running a tap that made a long tunnel and fed into a sandbox; there were days when a car wash in a neighbor's driveway would turn into an impromptu party with sprinkles; there were summer play dates with water balloons splashing on the sidewalk.

Concrete evidence of this drought in California: on my commute from Oakland to Davis, there used to be a lagoon near I-80. I'd often enjoyed seeing the water reflecting the sky from afar, the willows by the bank, the abundant grasses. A few years ago I began to notice the retreating waterfront until one day the willow trees reached in vain for the water. The grass did not come back. It has been dry for a few years now.

On a visit to Beijing, where I grew up, I noticed something that I had long forgotten. In my parents' bathroom there was a stack of basins. On the day of laundry, the basins were spread out, leaving barely enough space for one person to hop in and out of the bathroom.

I remembered the practice then: The water from the washer—each washing, each rinsing—would be saved in the basins in order. Water with detergent was used to wash the floor, and that from the first rinse was used for mopping after. Water from the second rinse was used for wiping. Only then, after it had been recycled already, could the water be used to flush the toilet. To use fresh, clean water to flush the toilet was a horrendous waste, a sin even. The water for gardening never came out of the tap—it was saved from washing vegetables, rinsing rice, or other cooking tasks.

Water has never been taken for granted in Beijing. When we grew up, the fear of the city being devoured by the desert was instilled in every one of us. Every drop of water saved was a drop to perpetuate the city's life. There is no art in that narrative: we don't leave beautiful bronze or pottery or stoneware in museums; instead we have, in each family, a stack of plastic basins.

Photographs

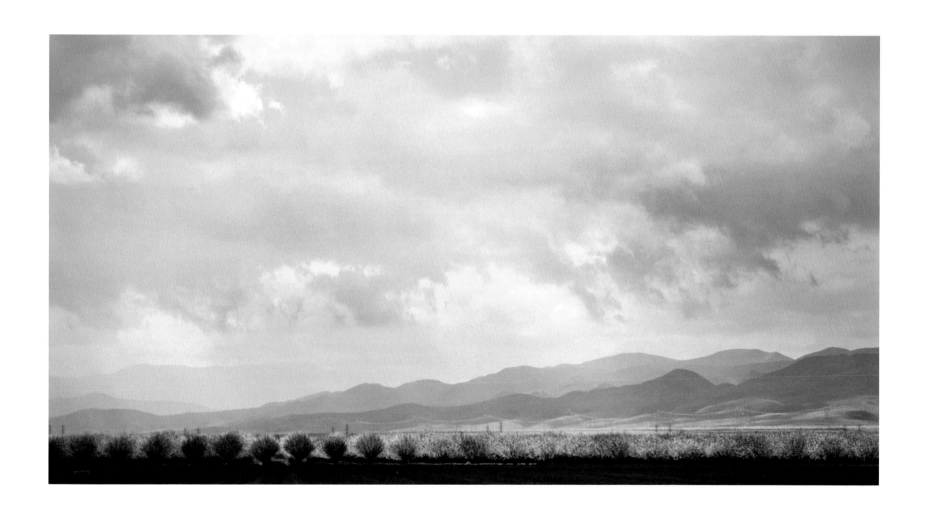

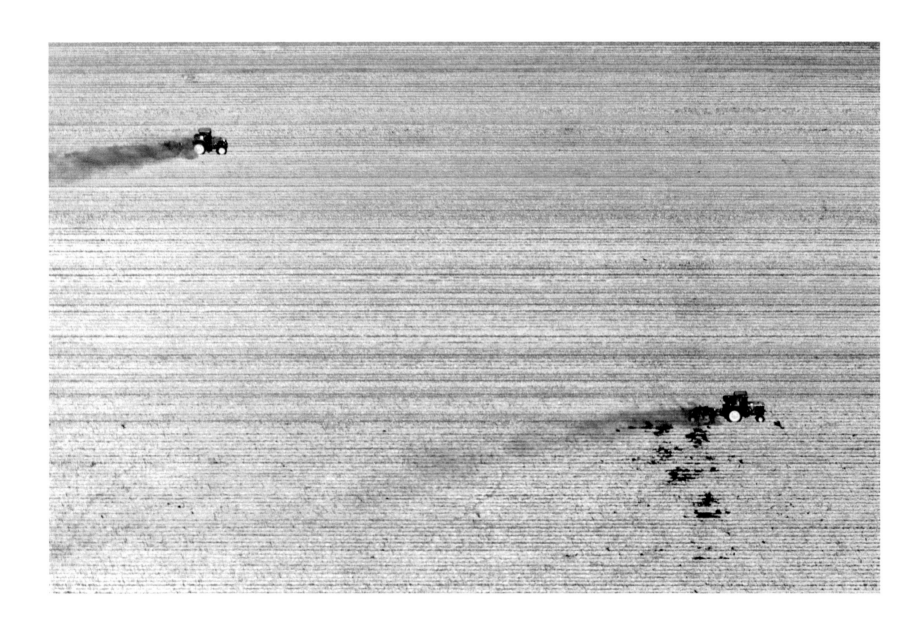

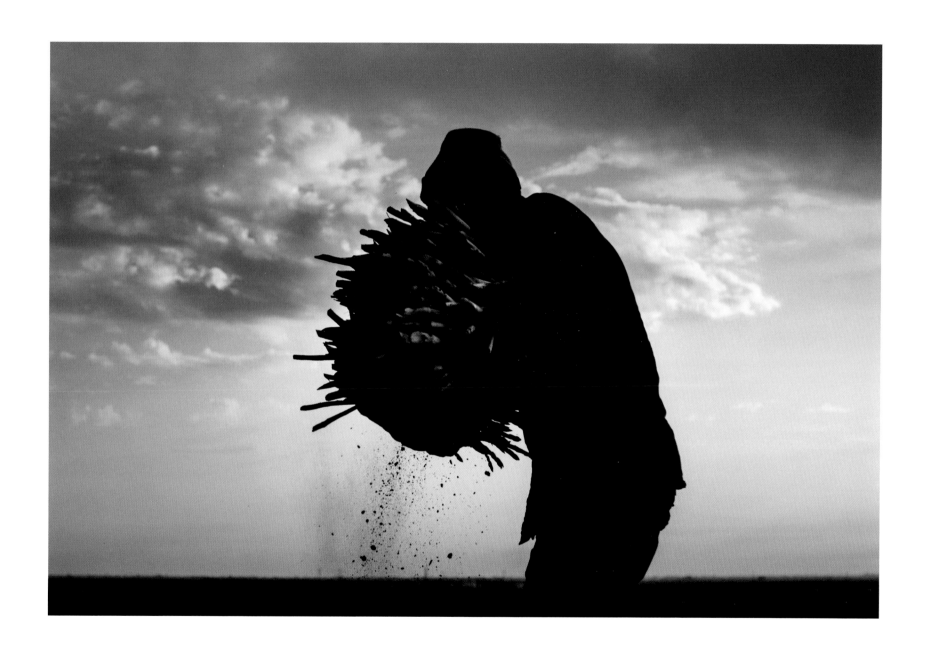

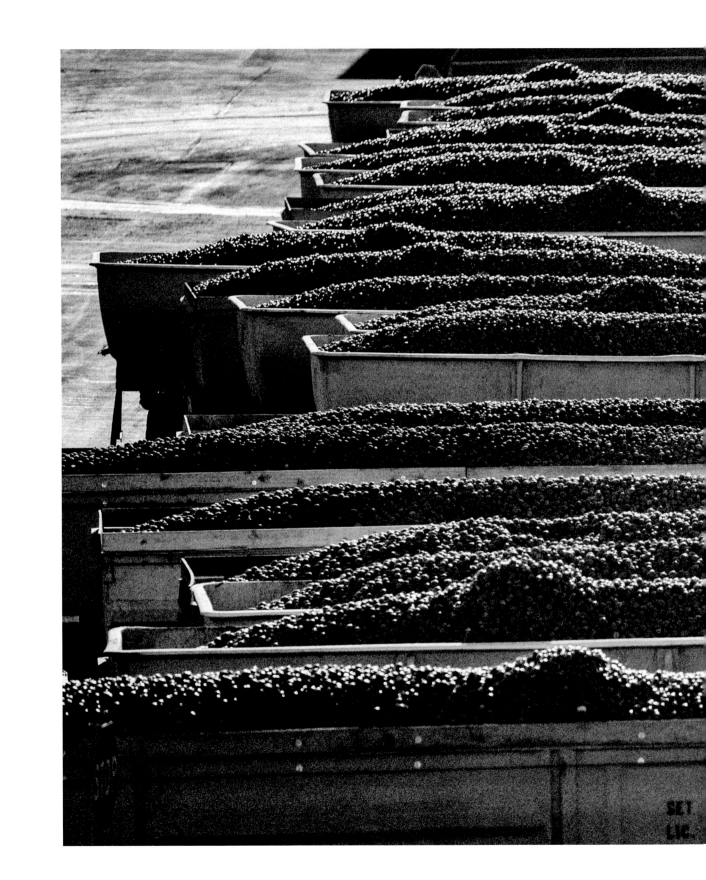

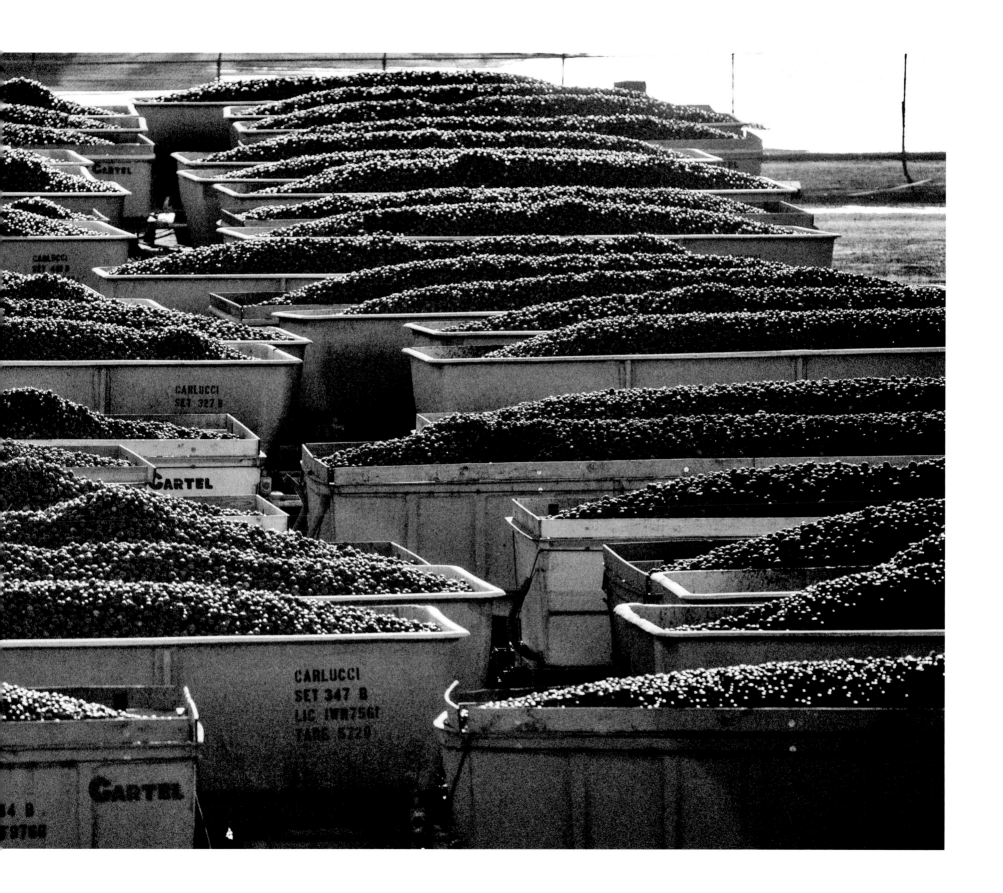

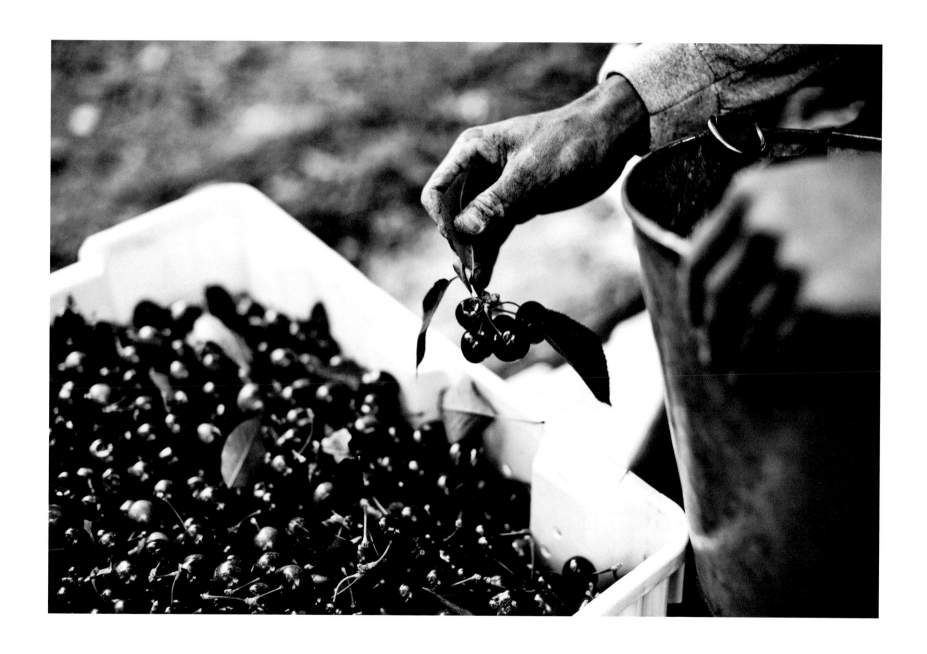

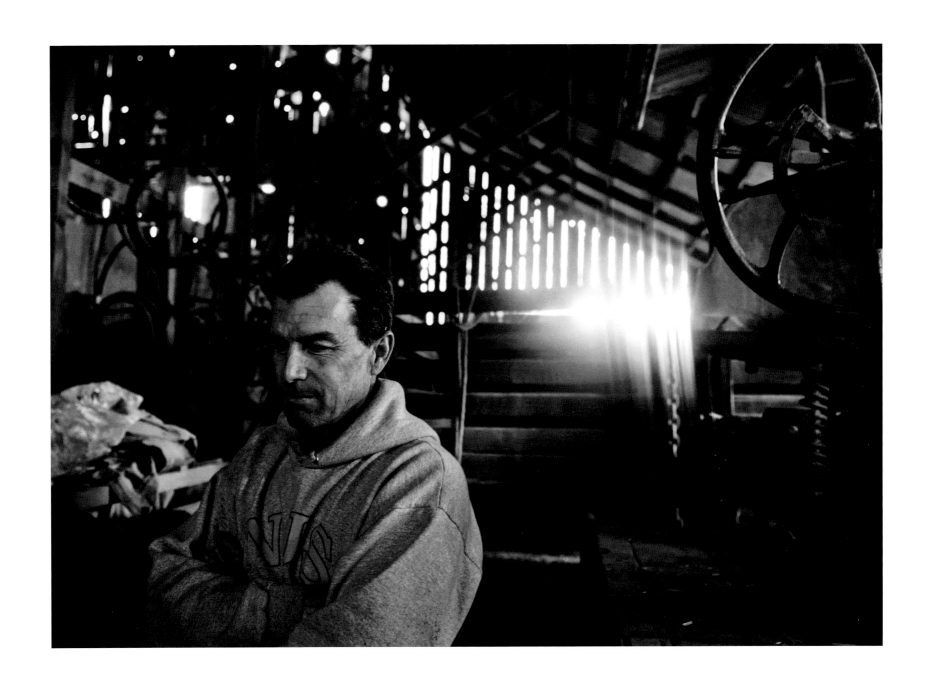

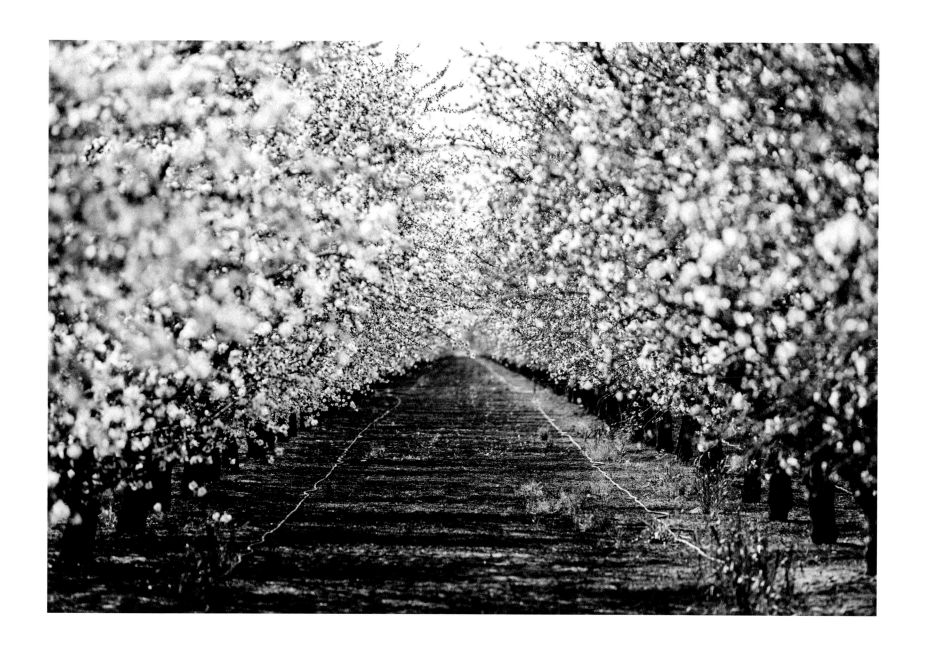

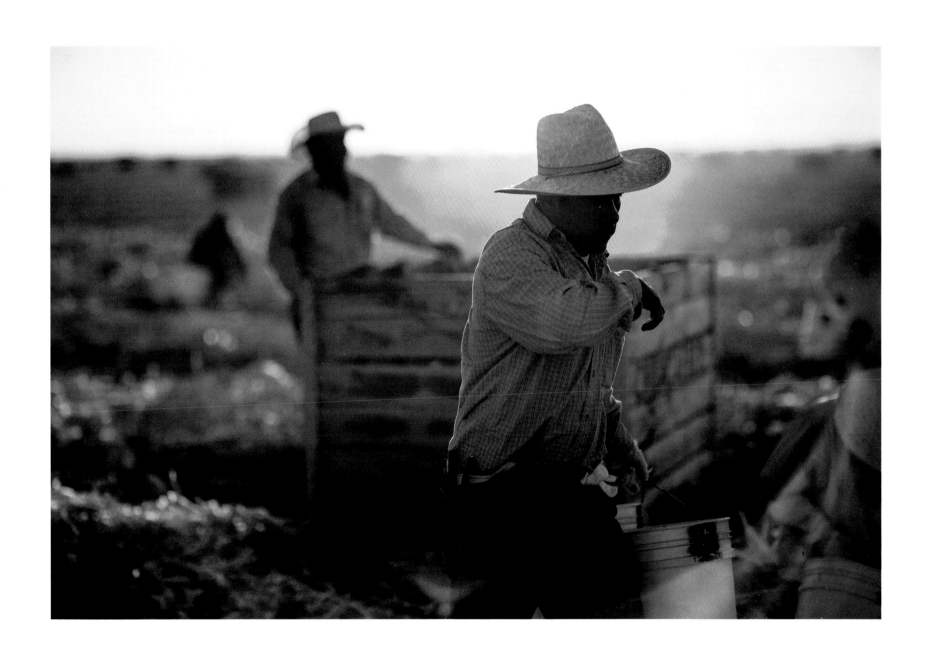

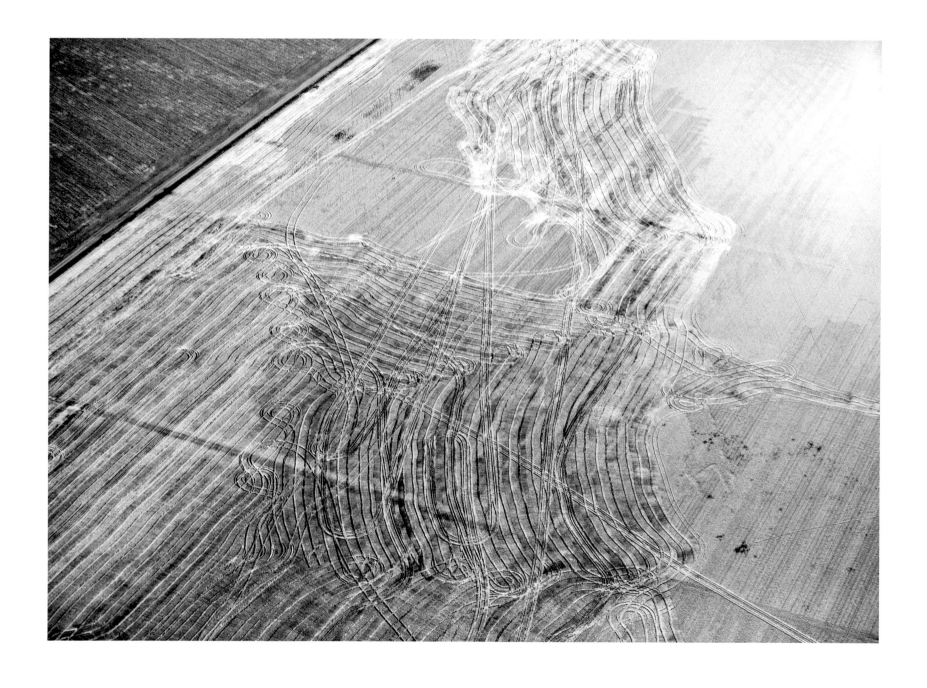

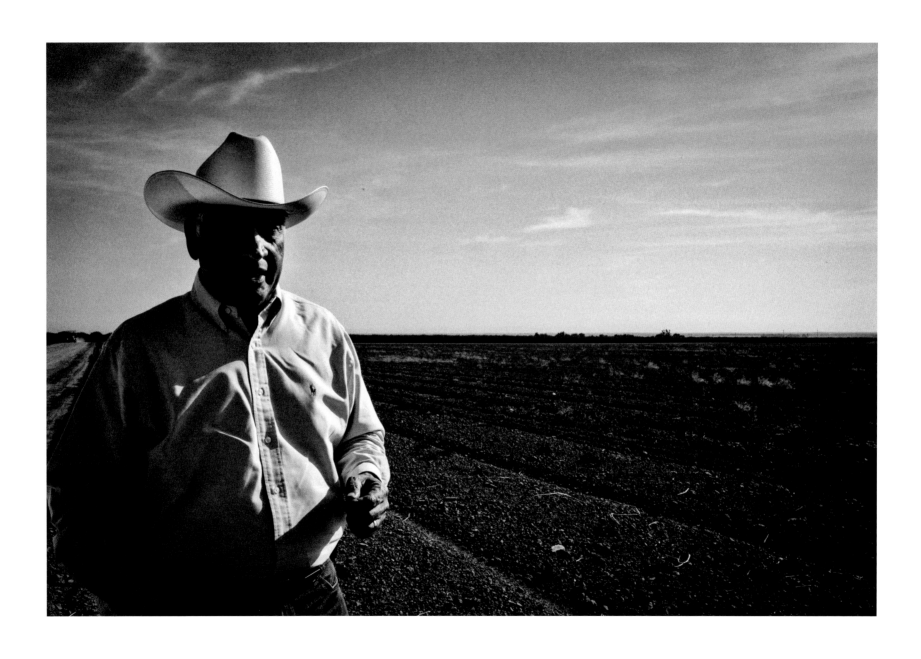

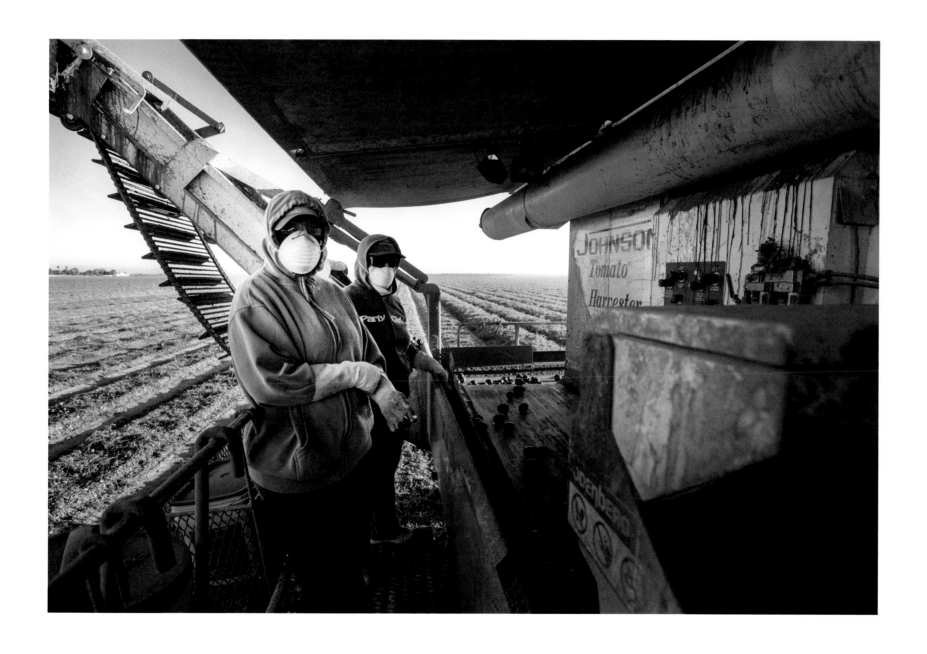

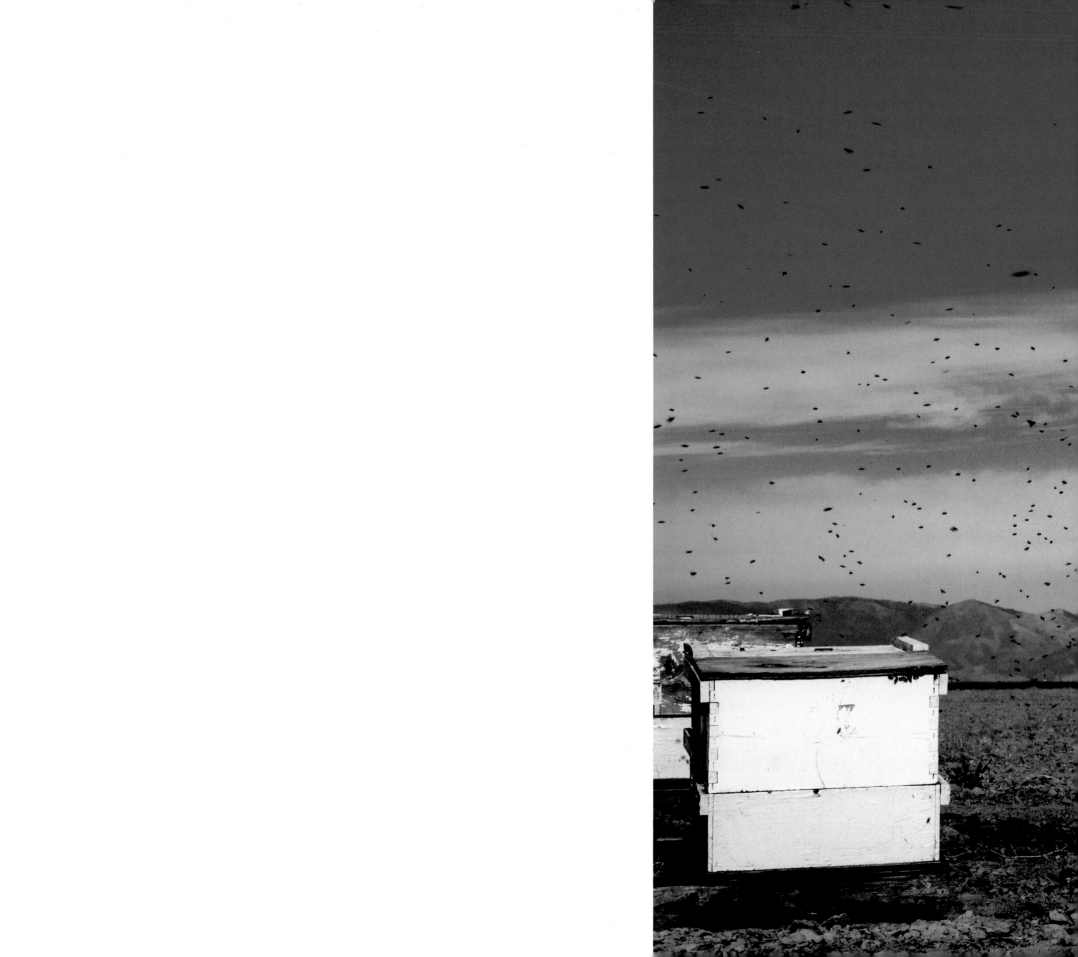

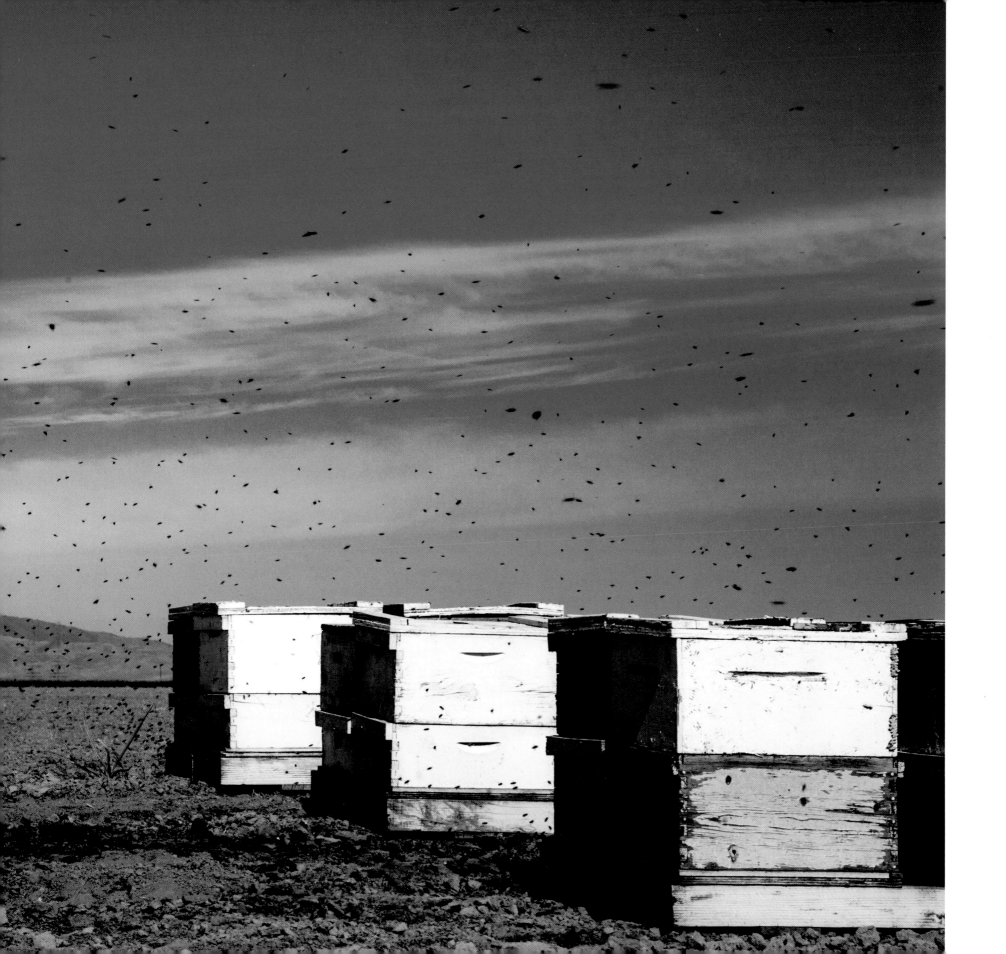

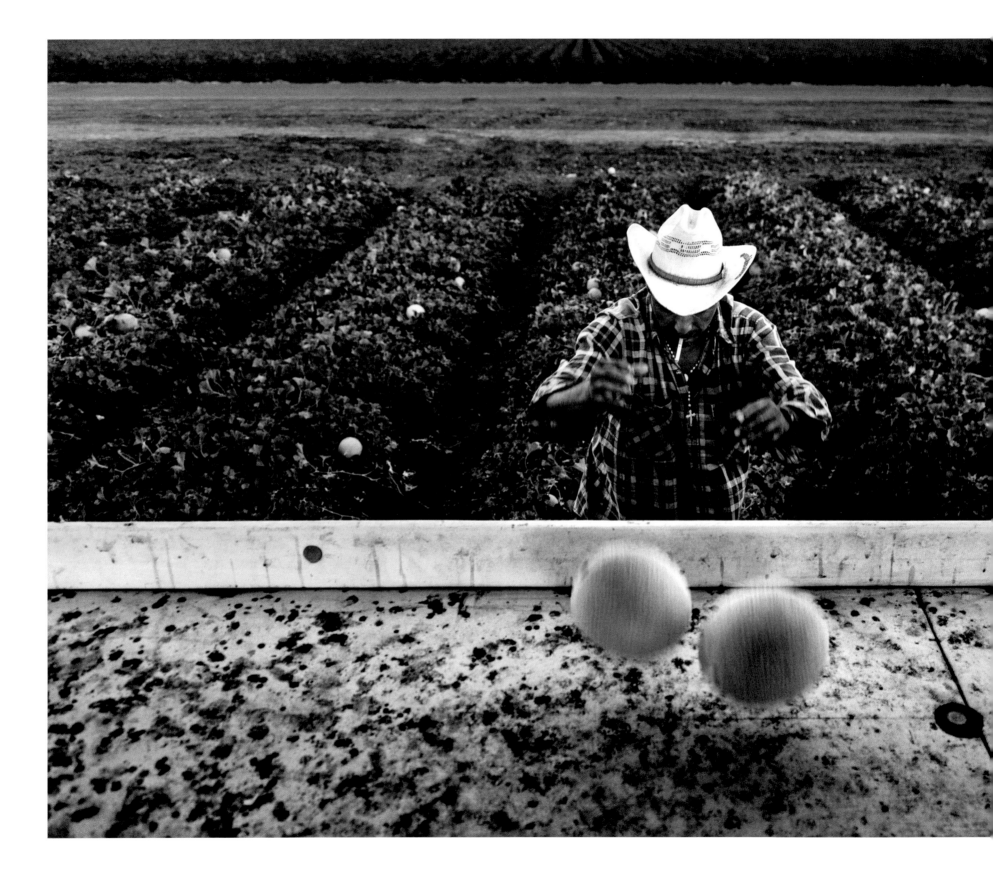

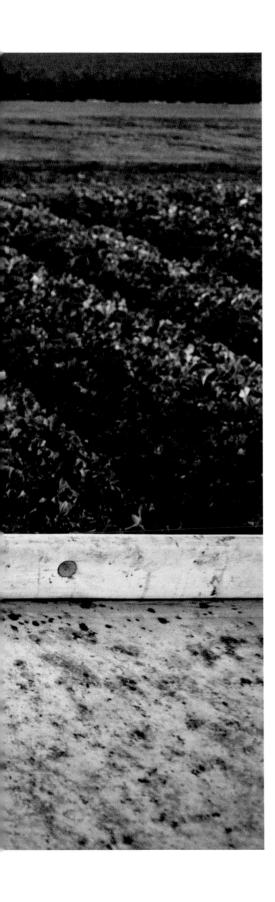

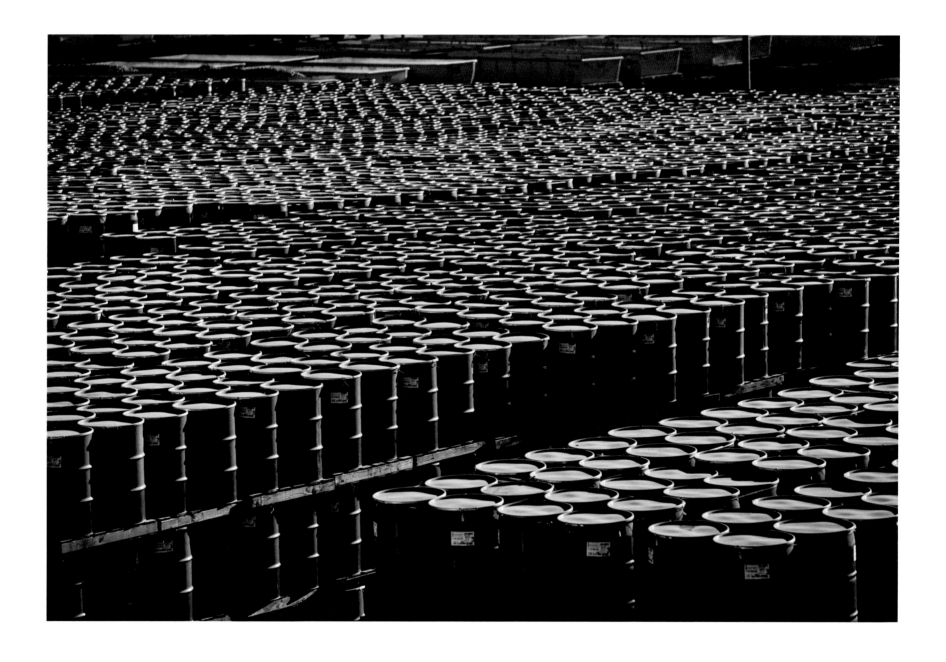

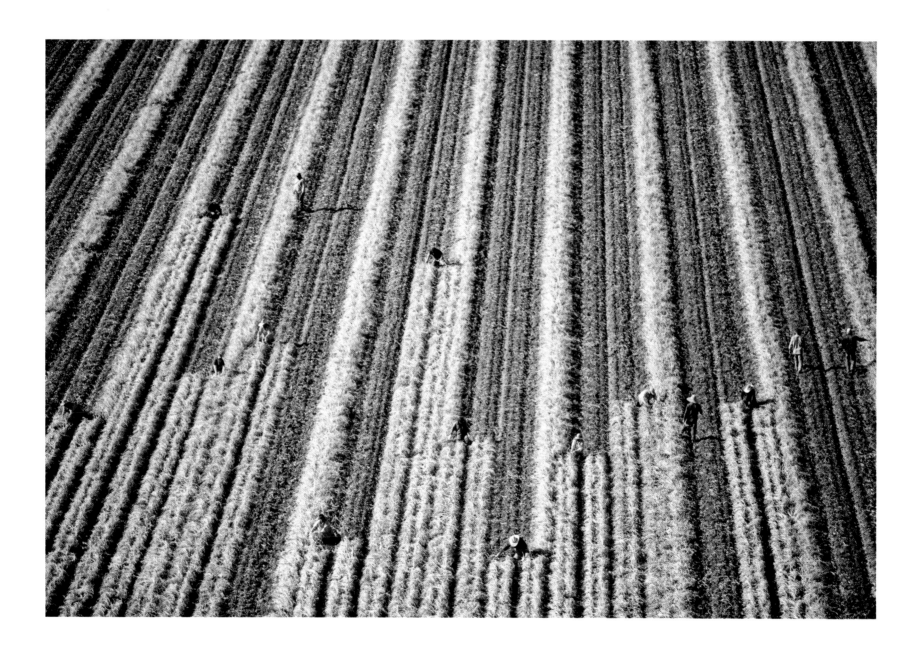

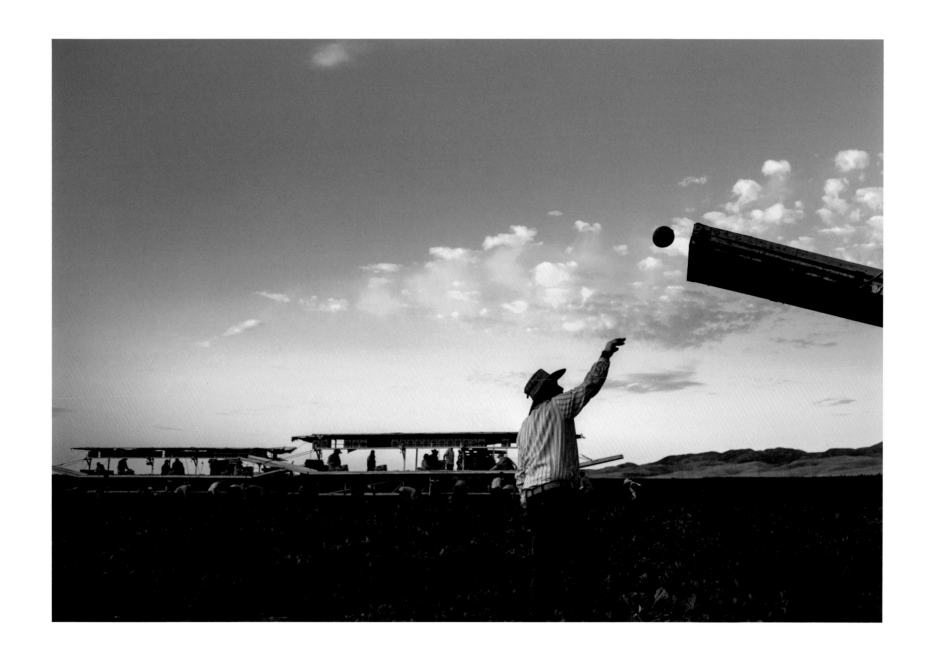

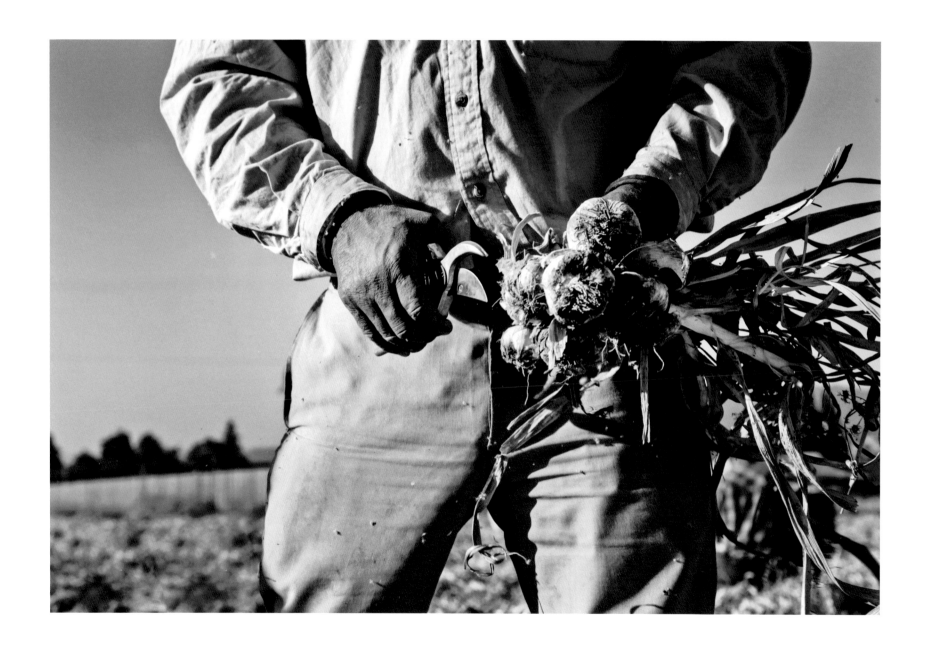

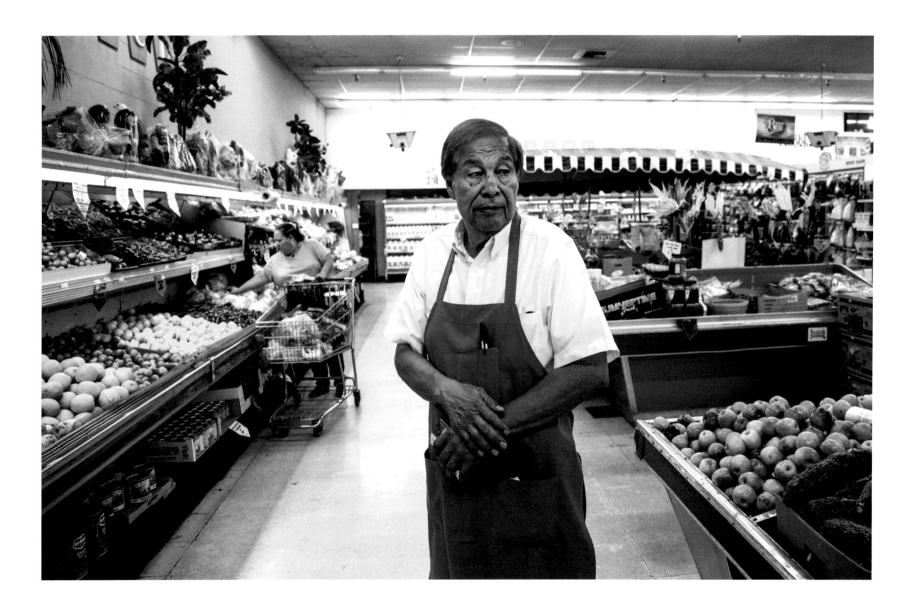

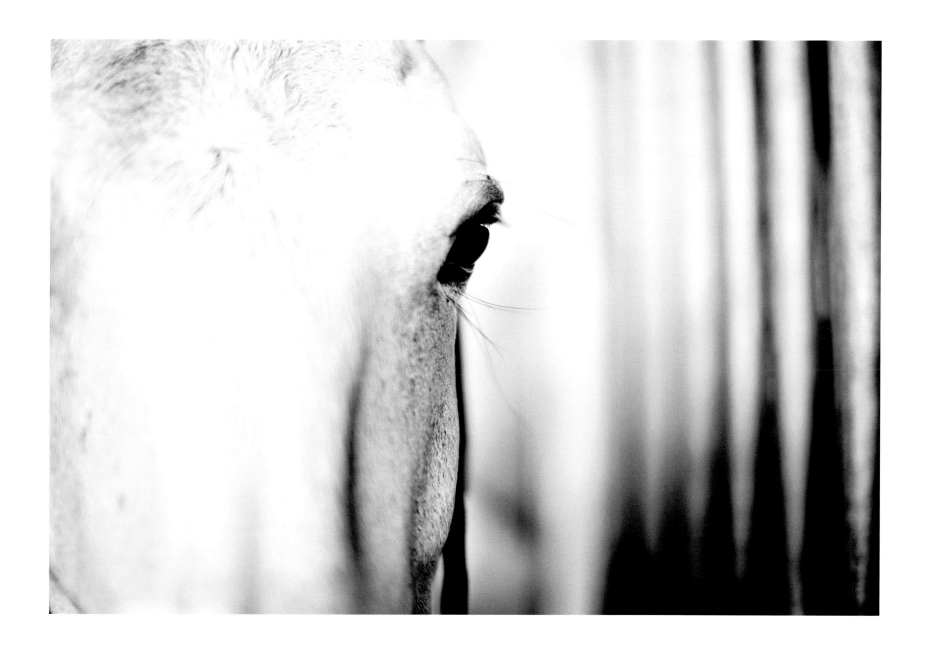

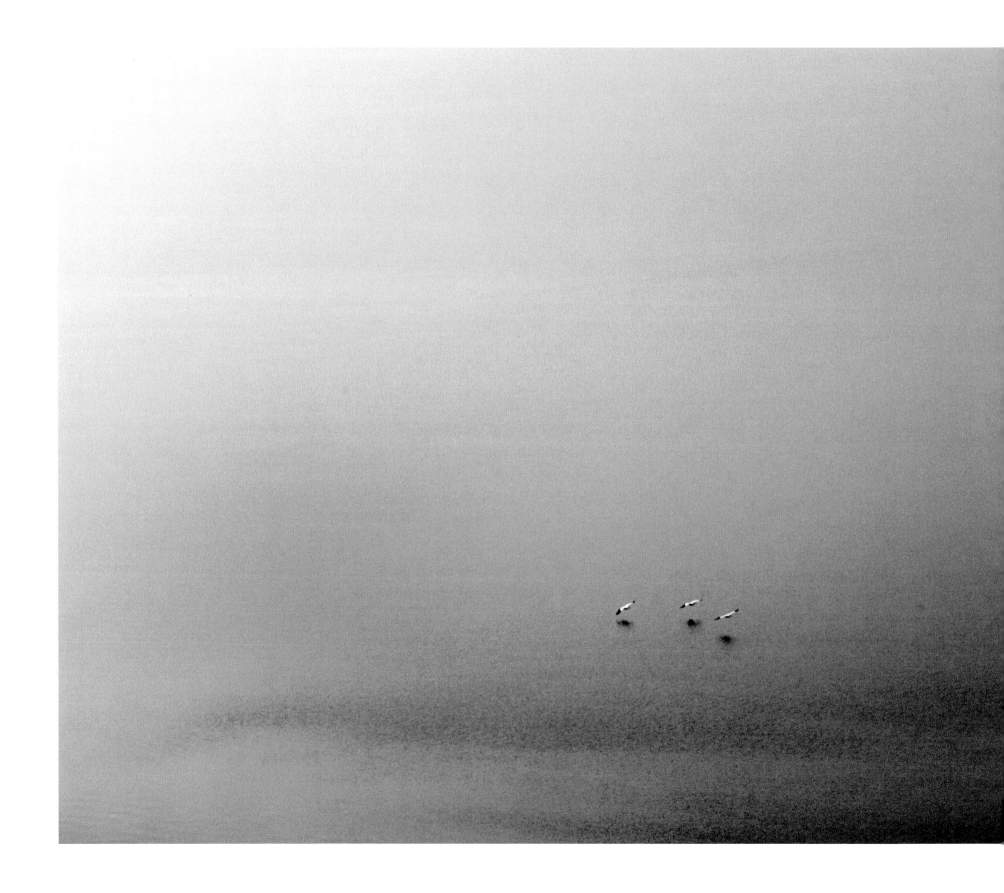

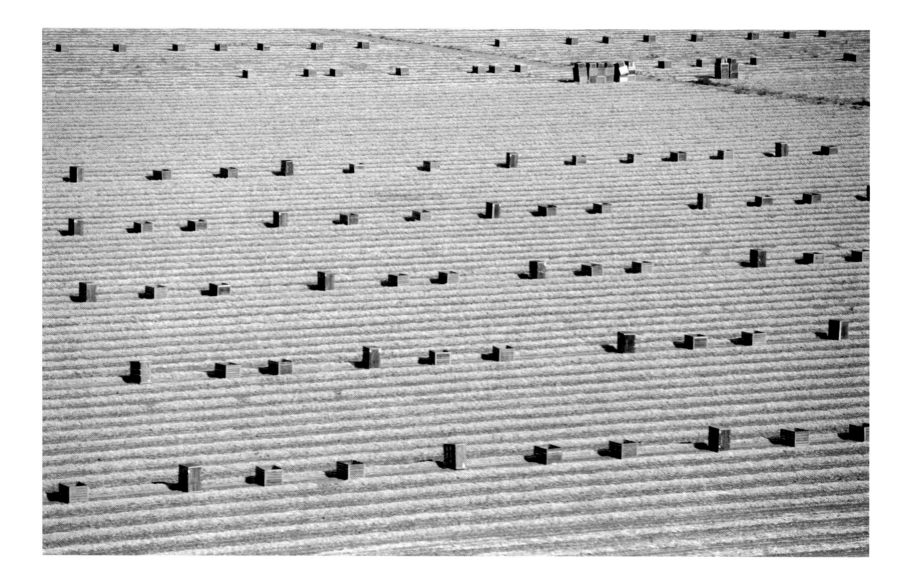

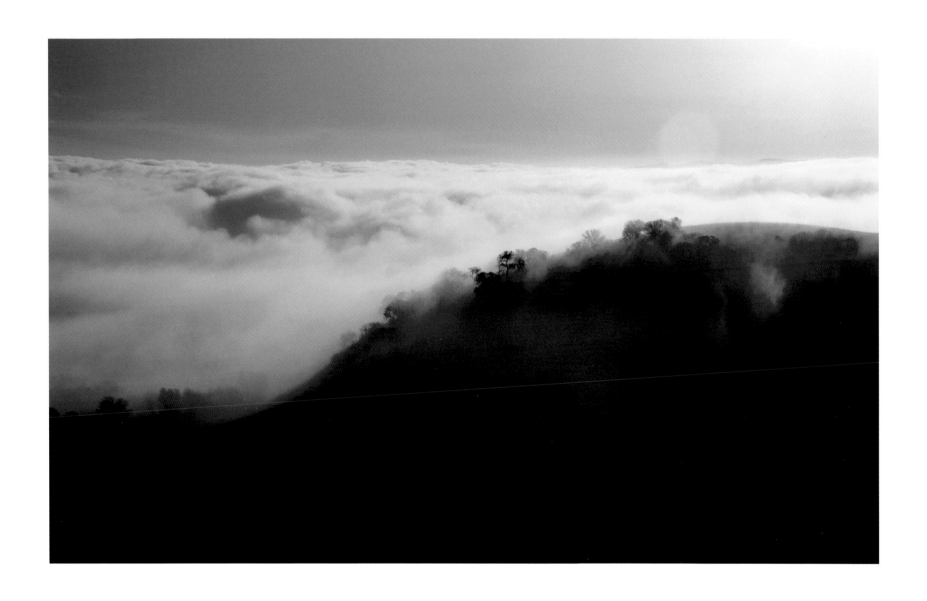

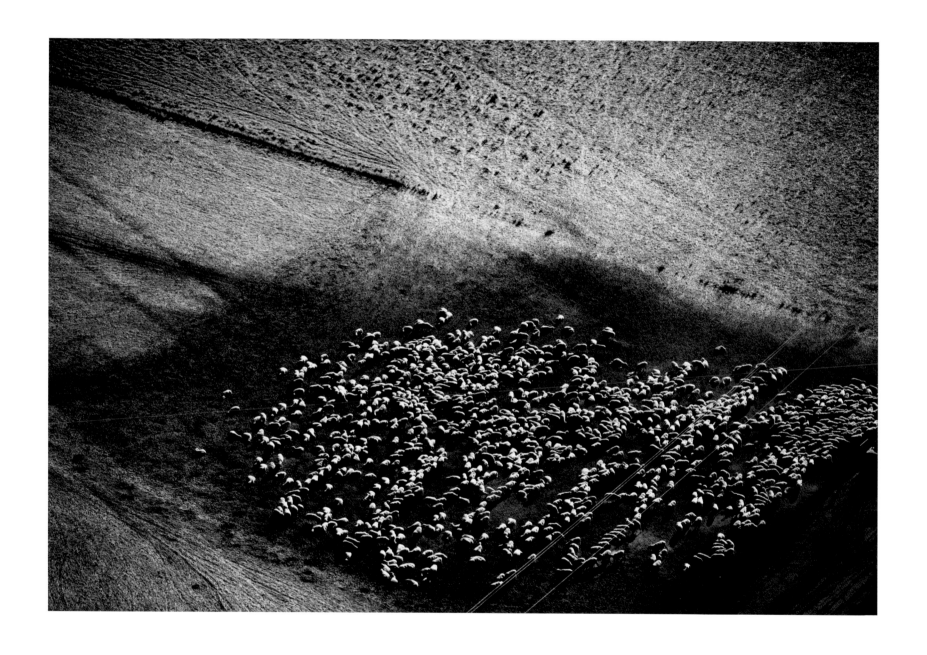

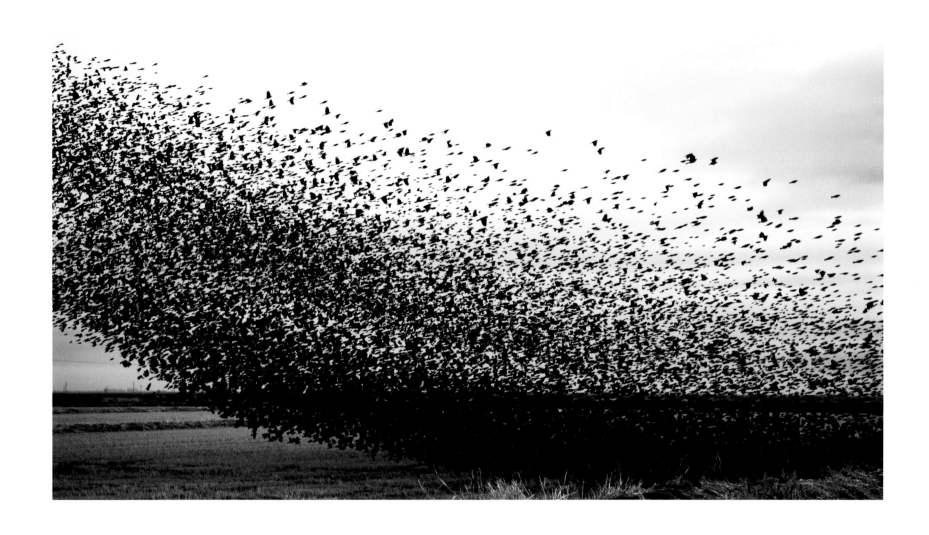

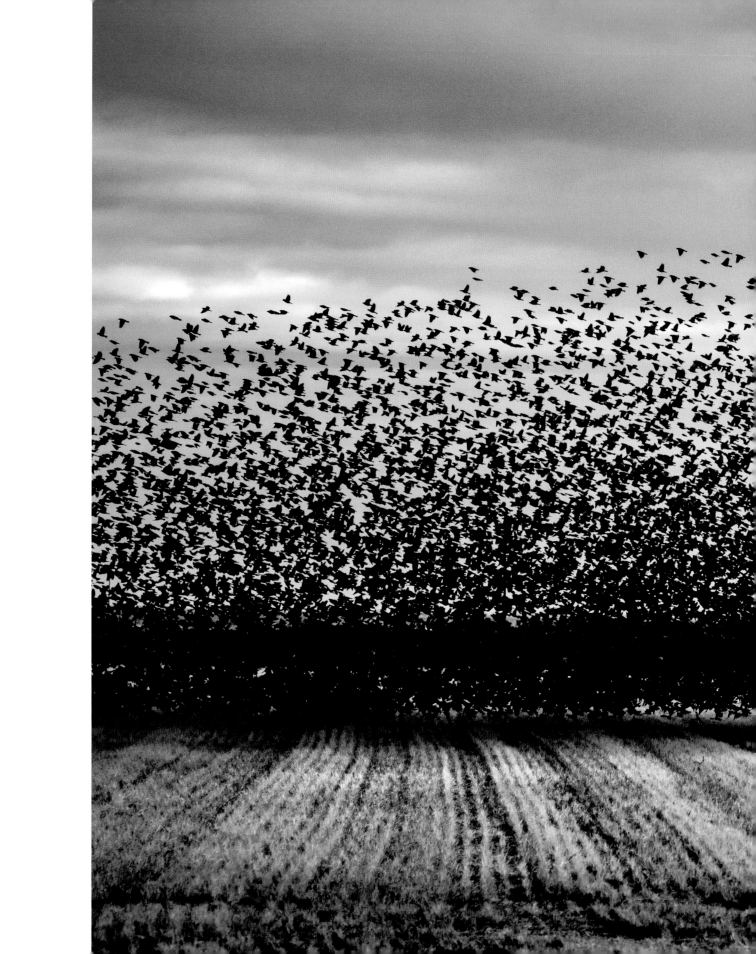

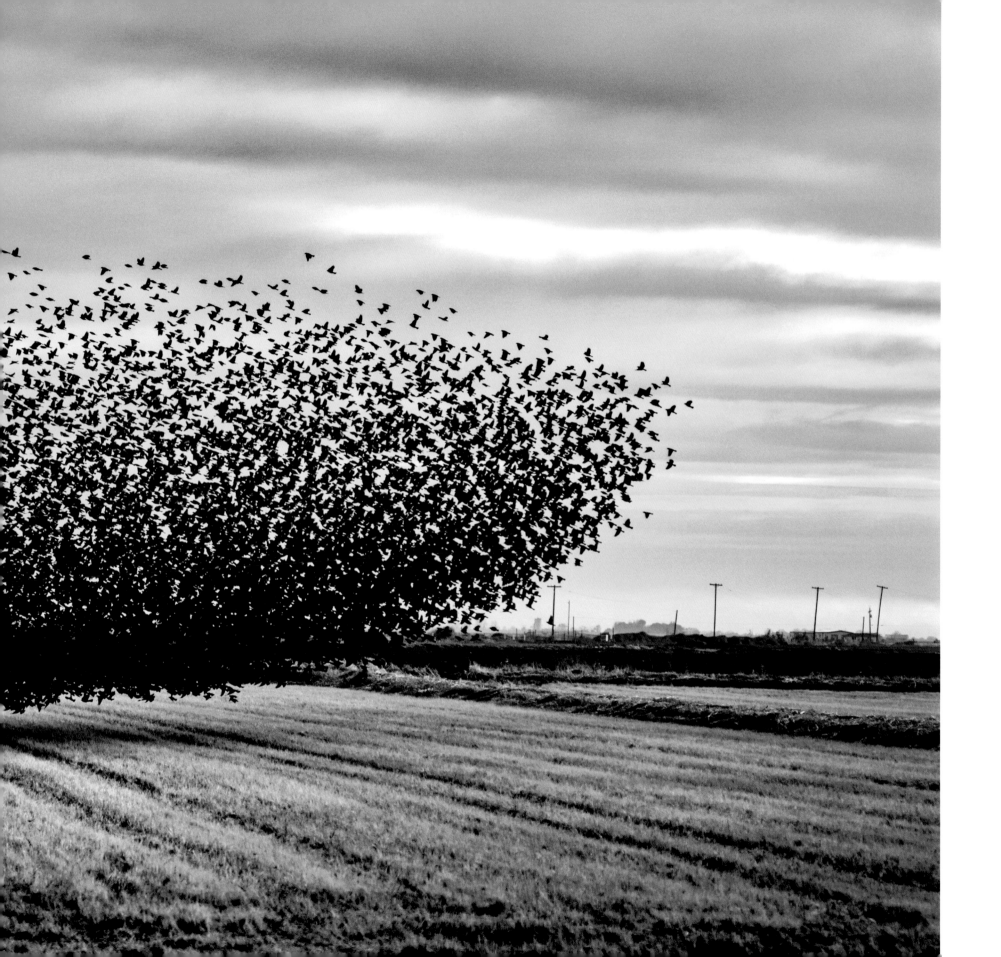

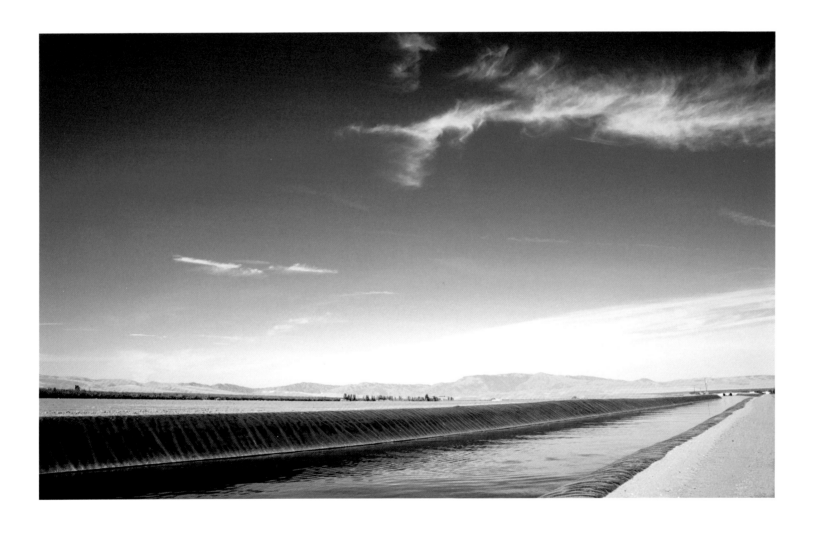

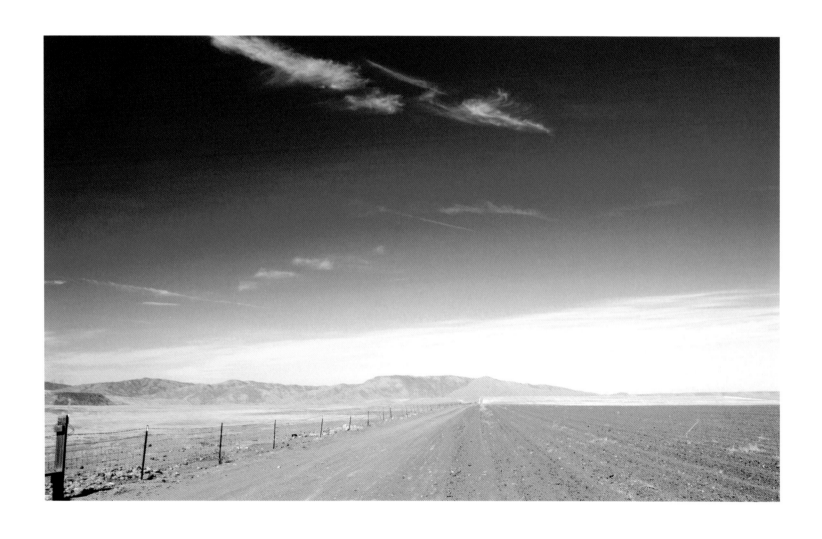

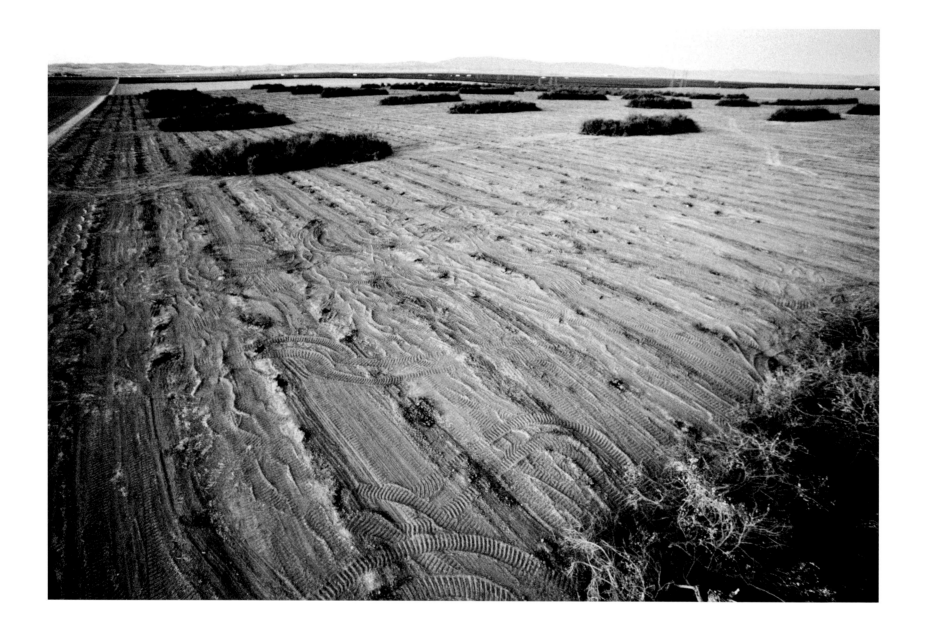

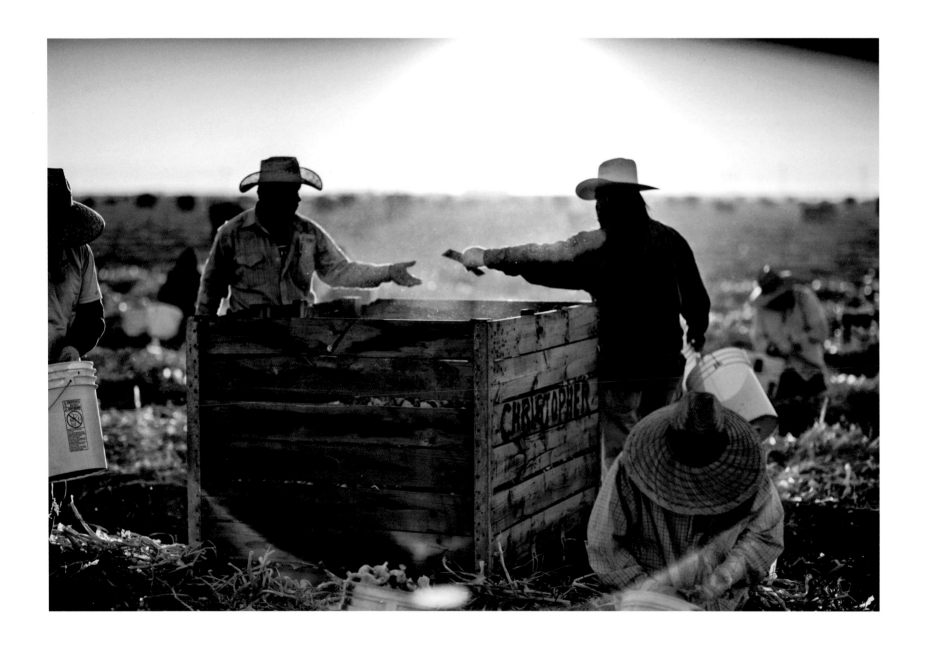

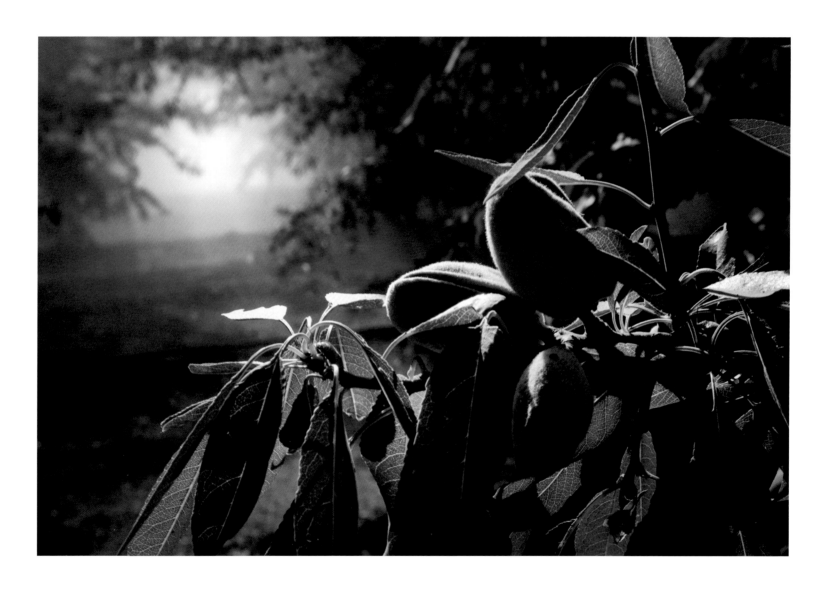

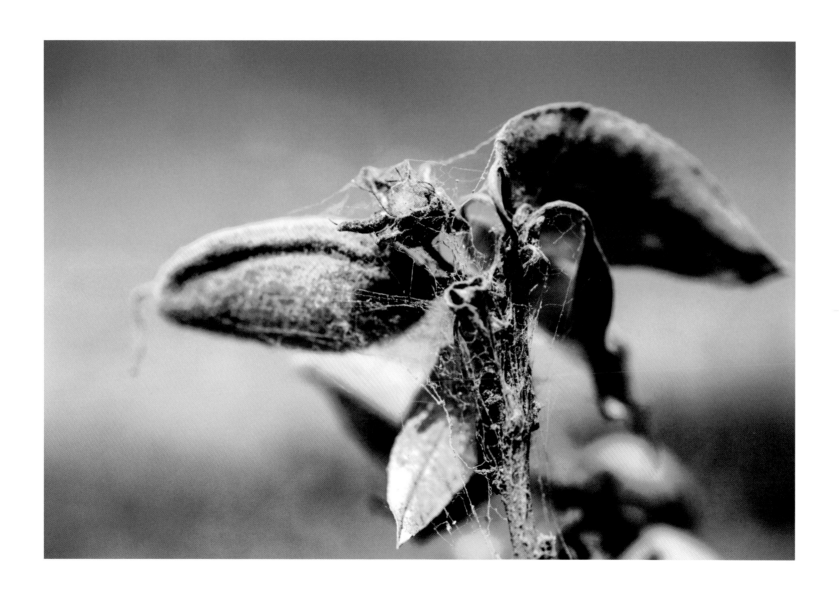

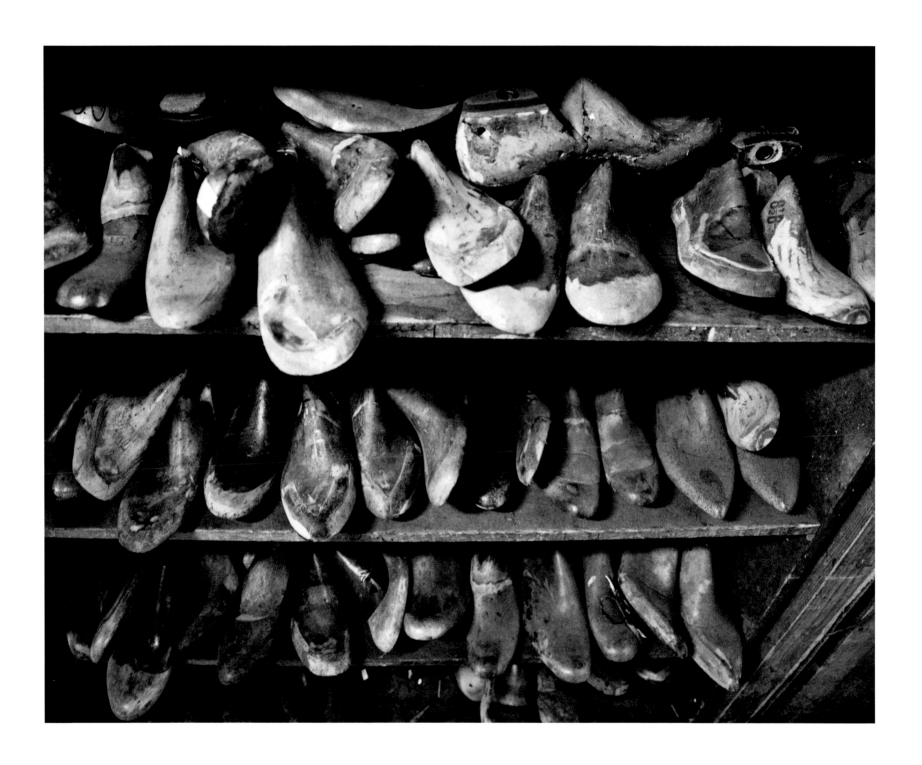

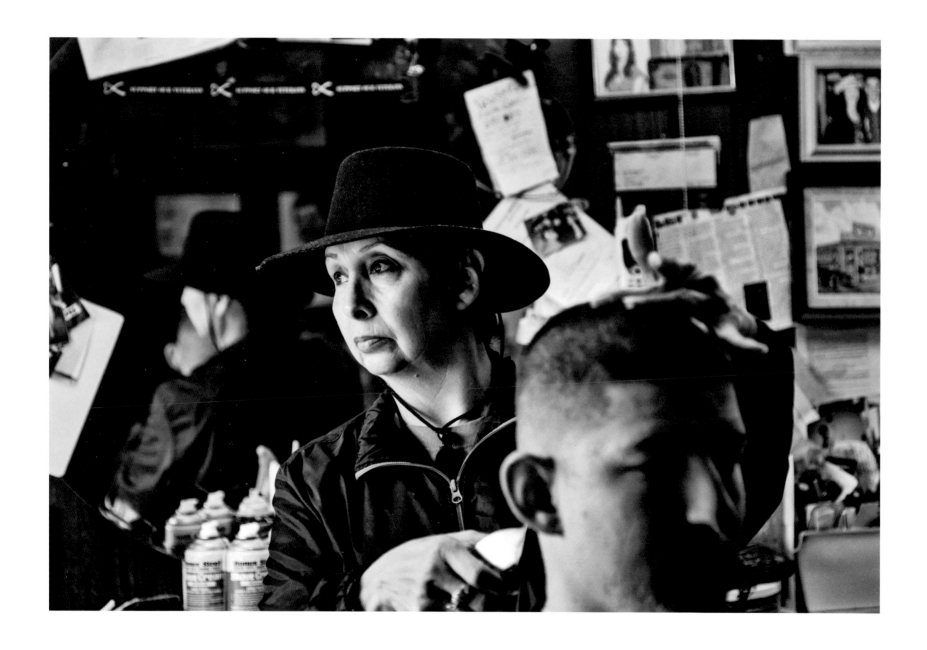

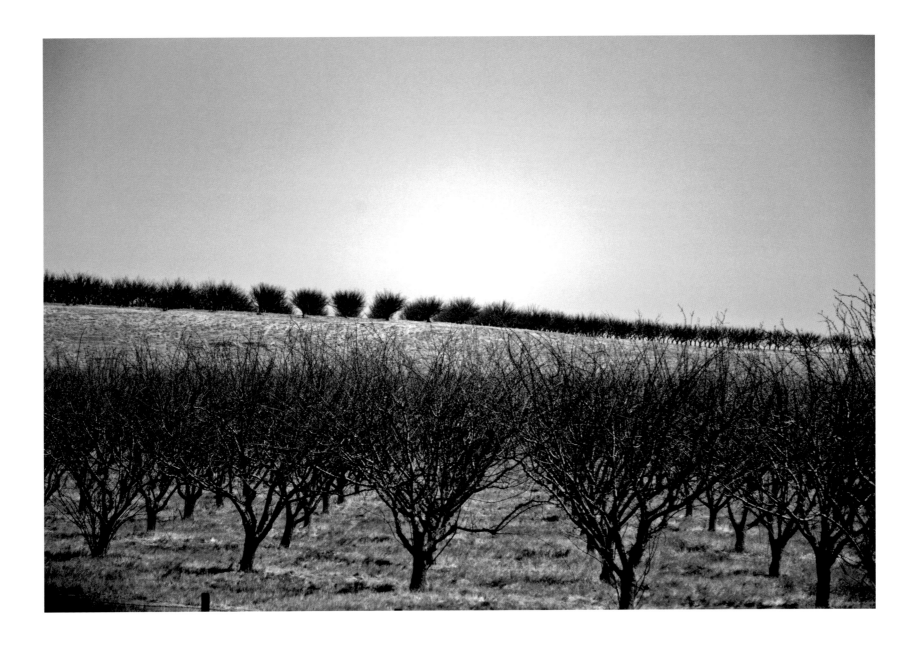

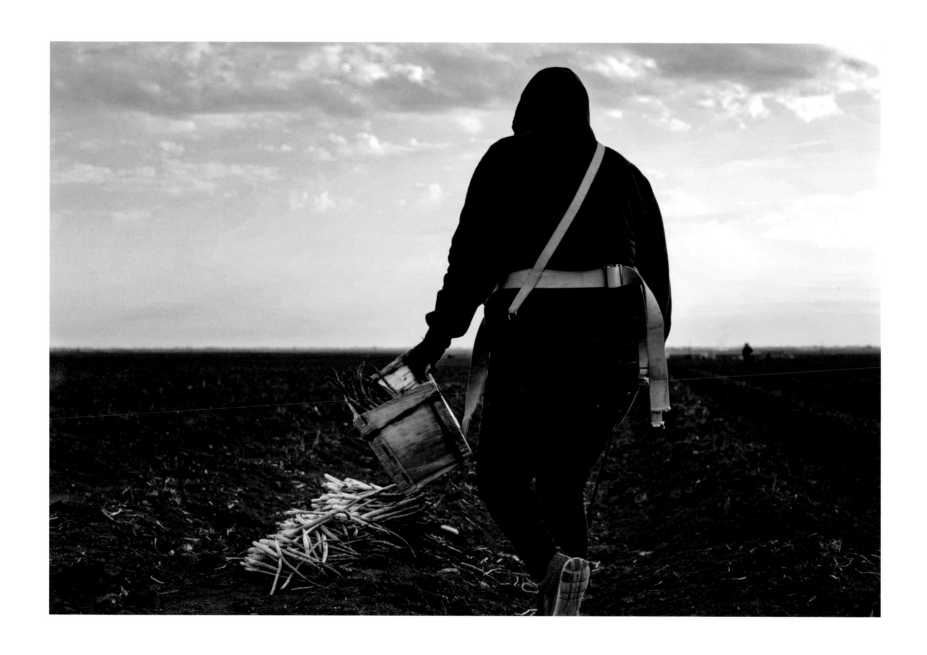

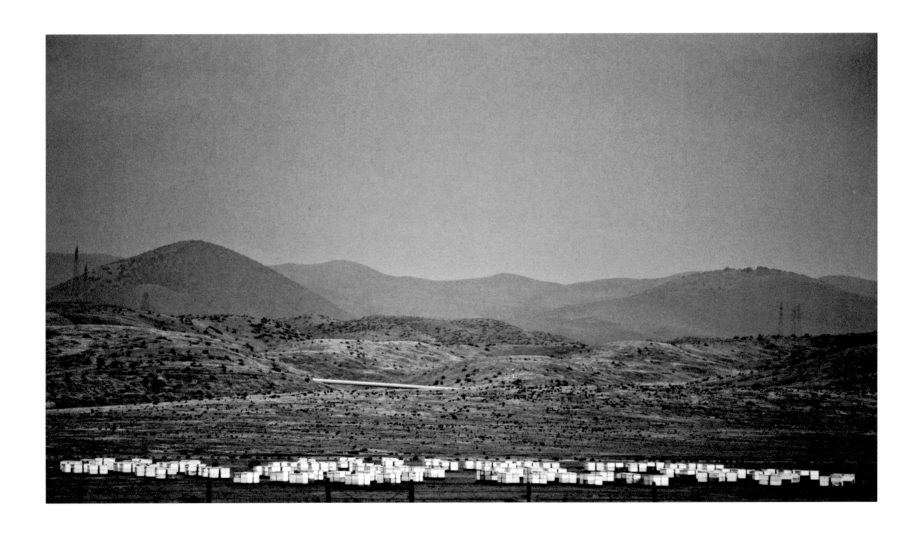

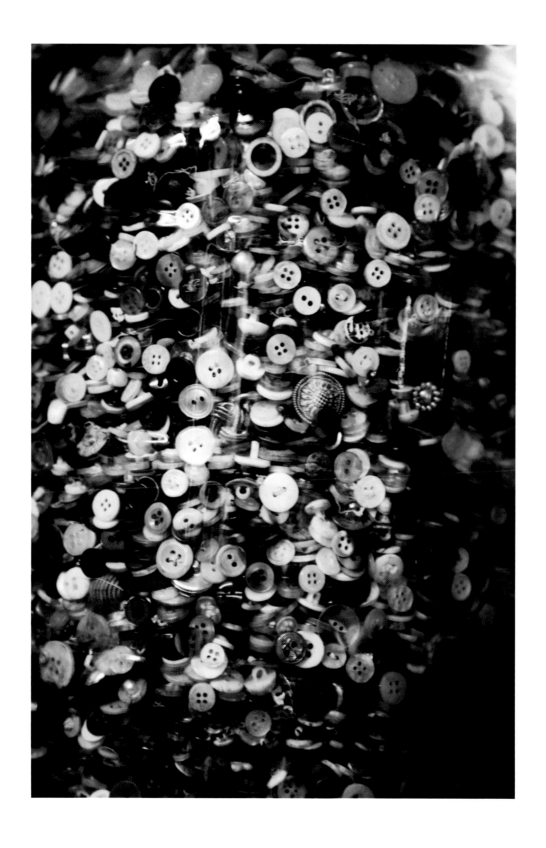

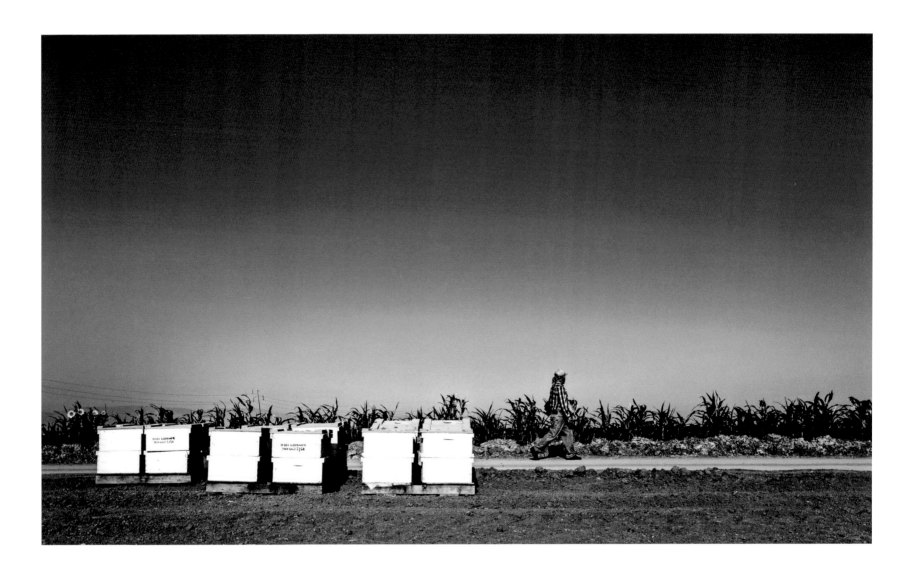

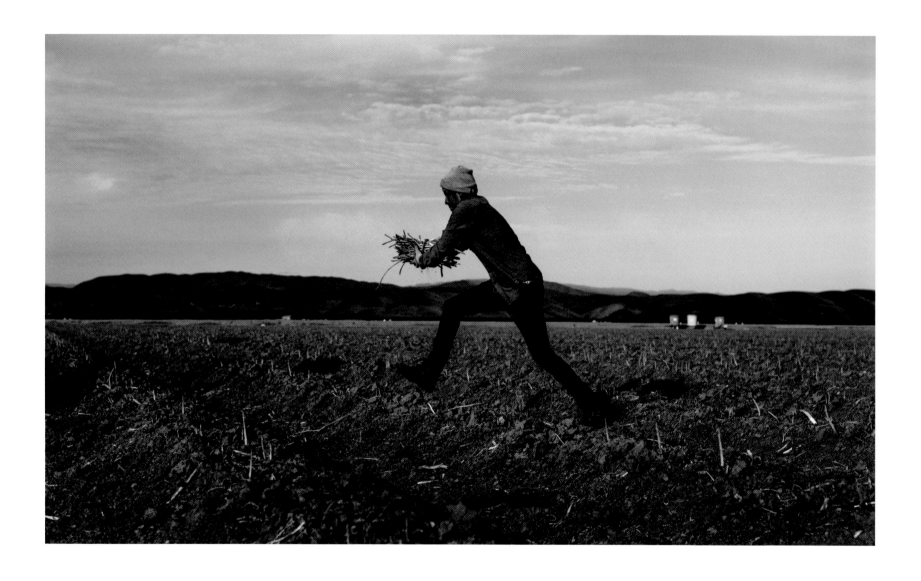

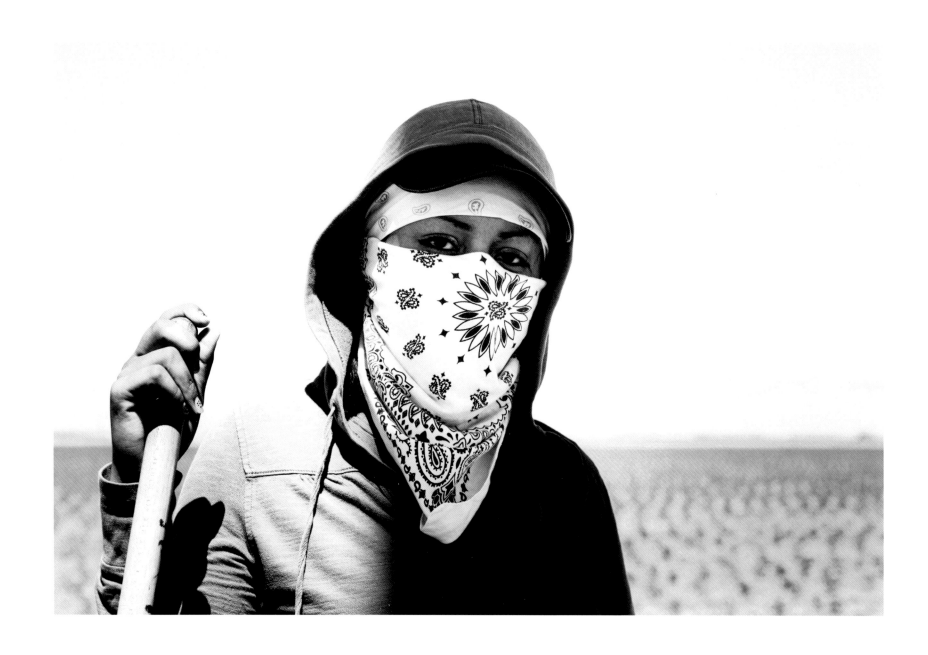

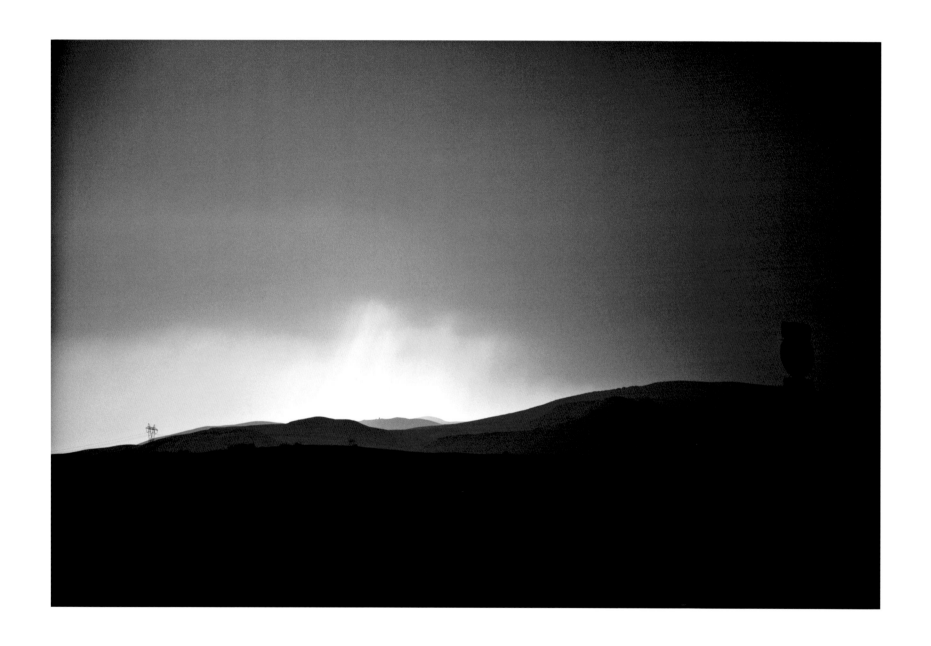

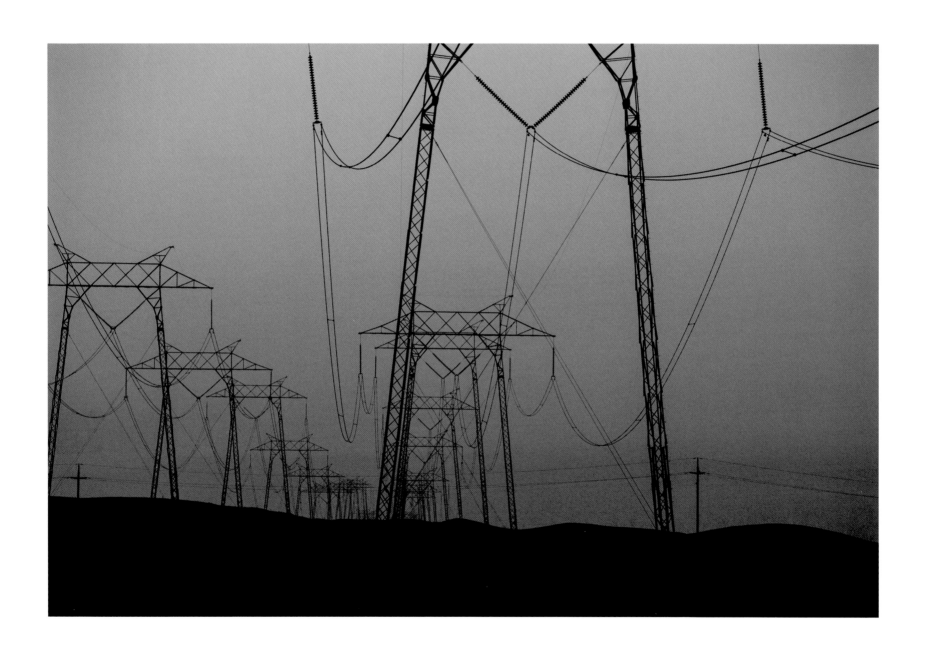

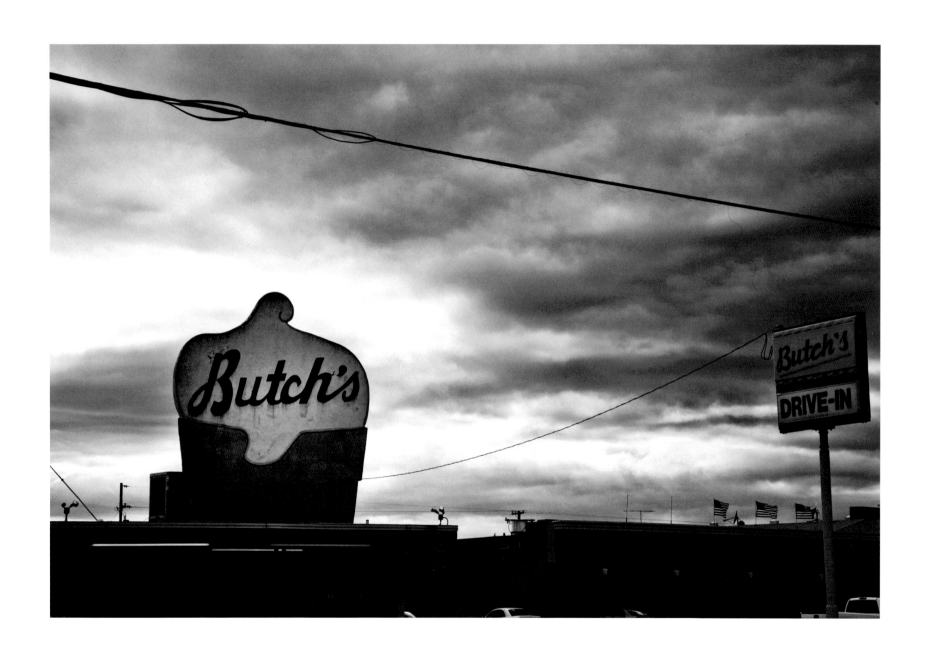

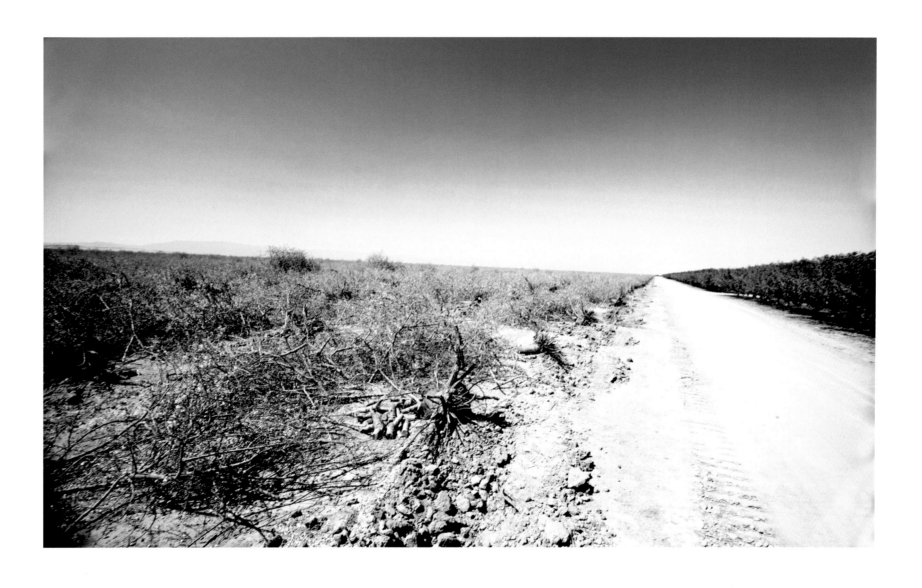

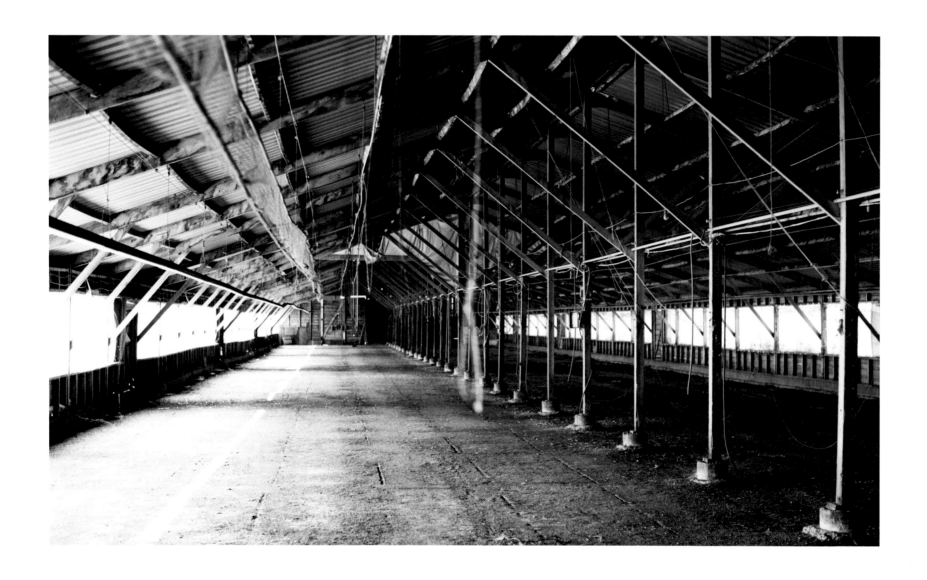

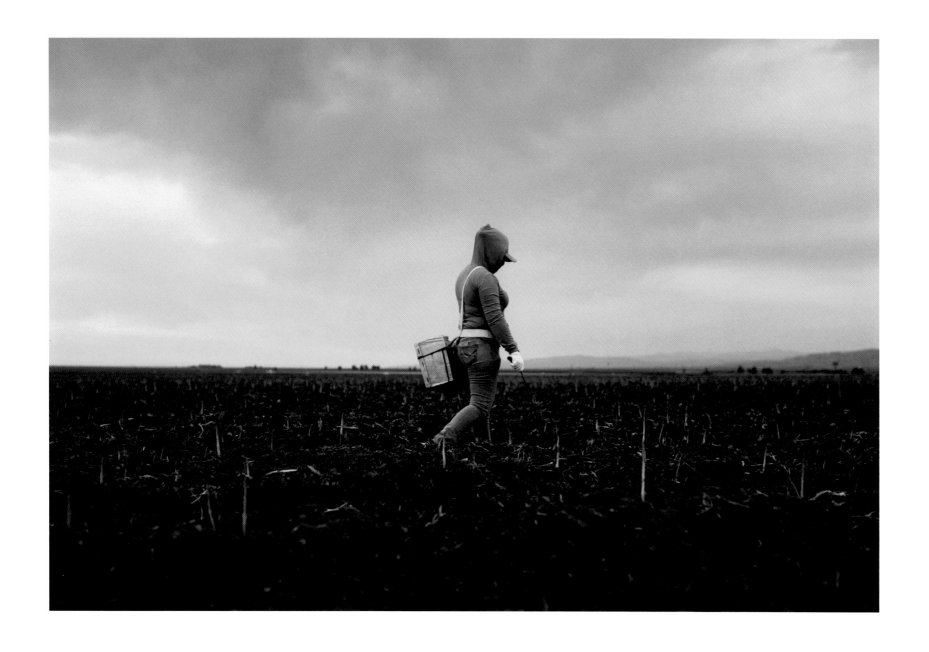

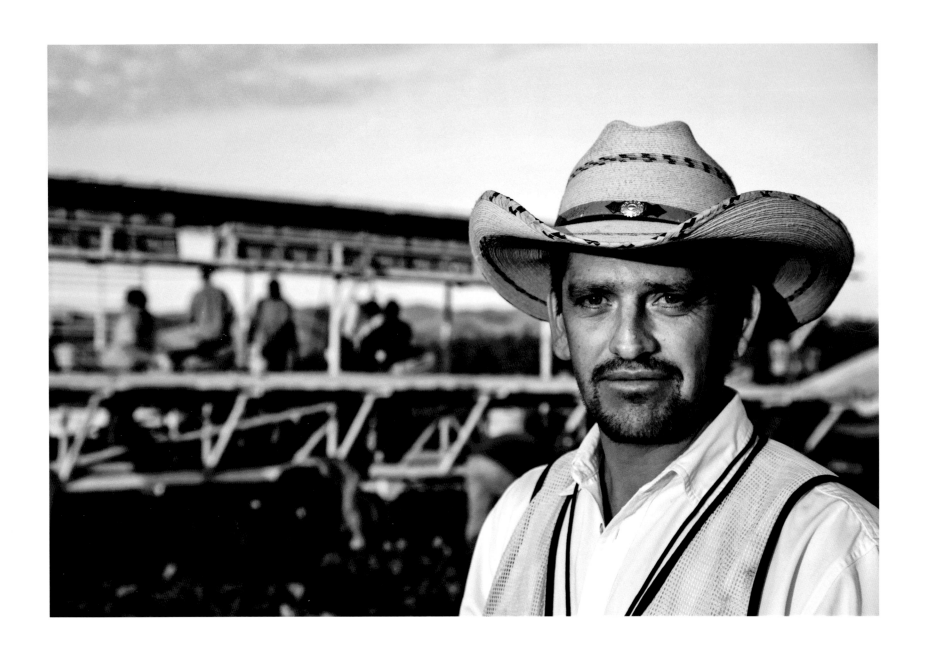

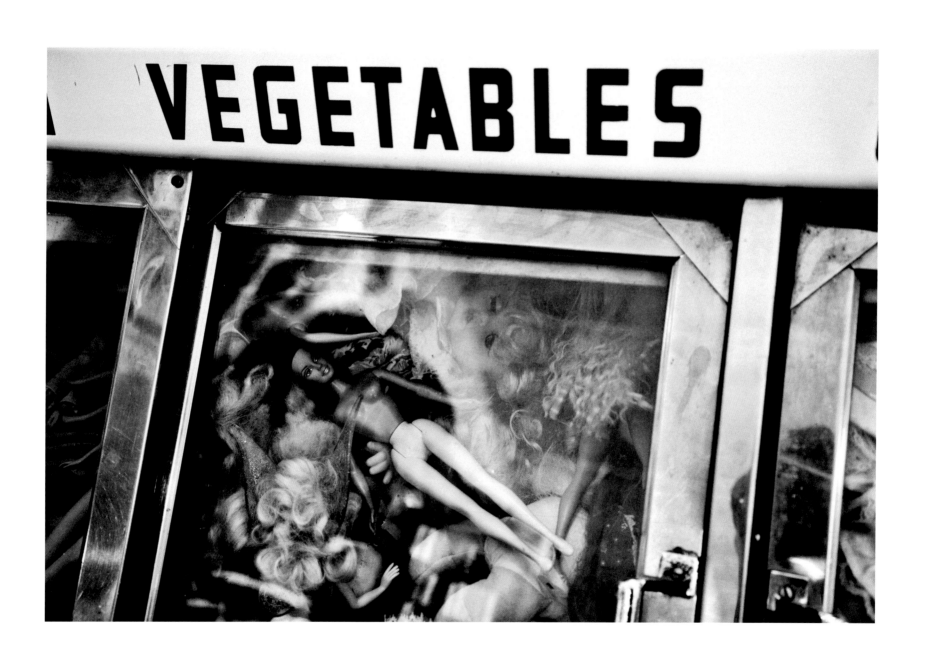

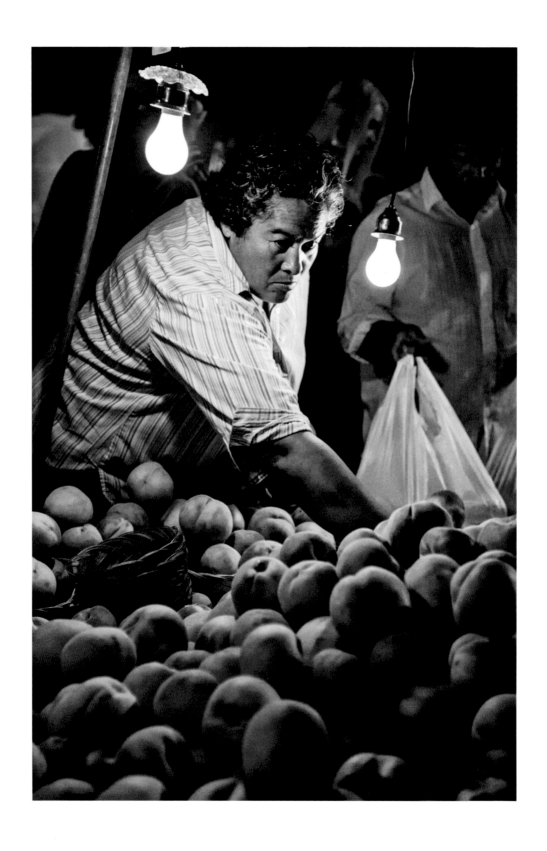

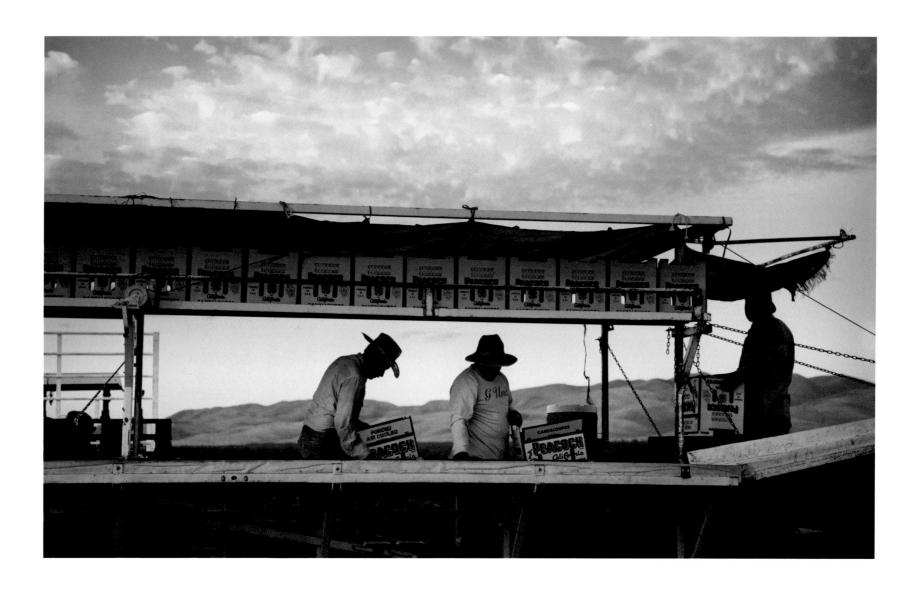

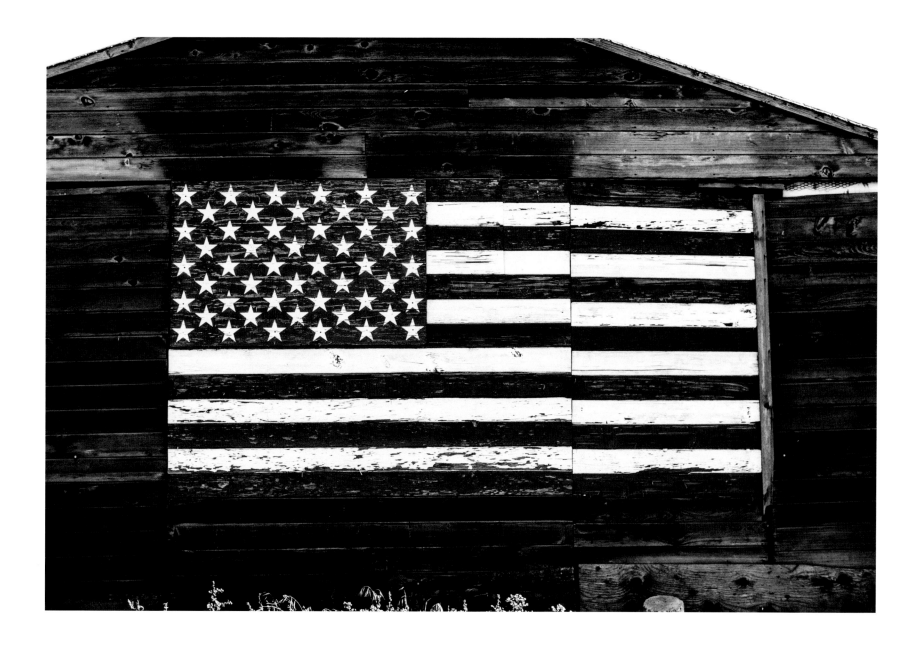

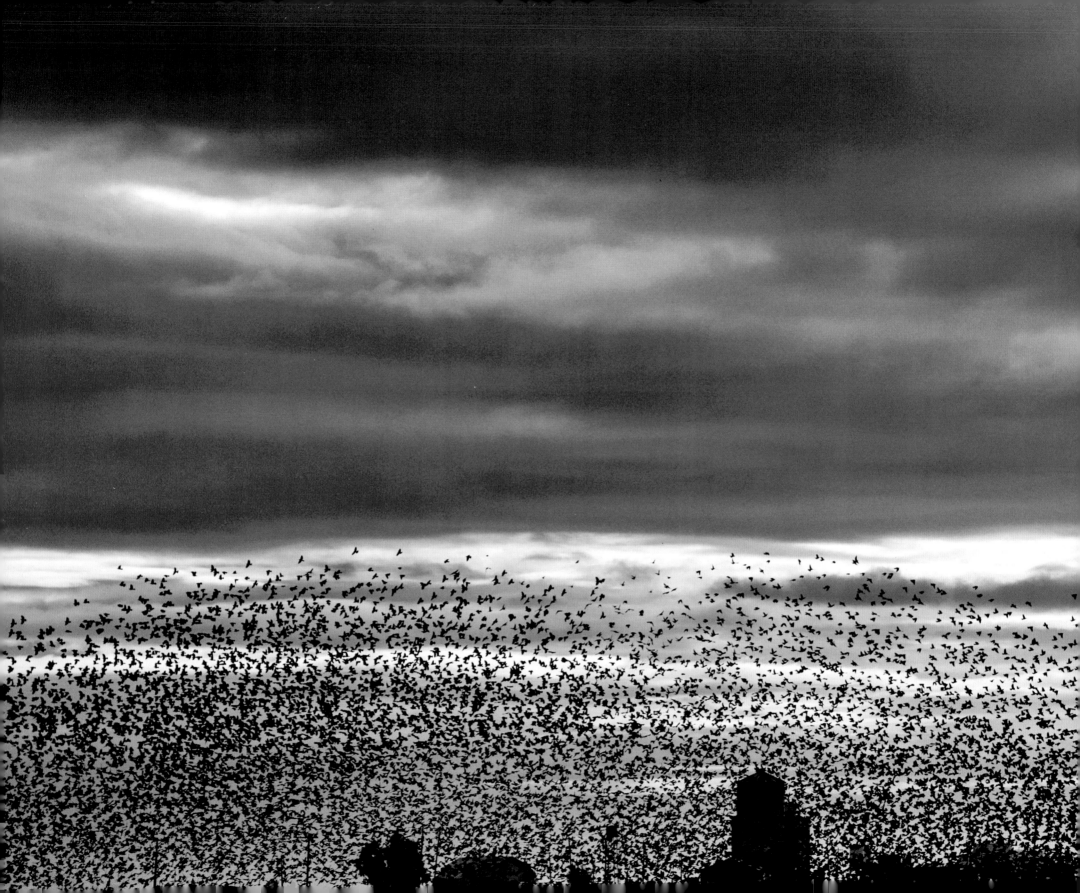

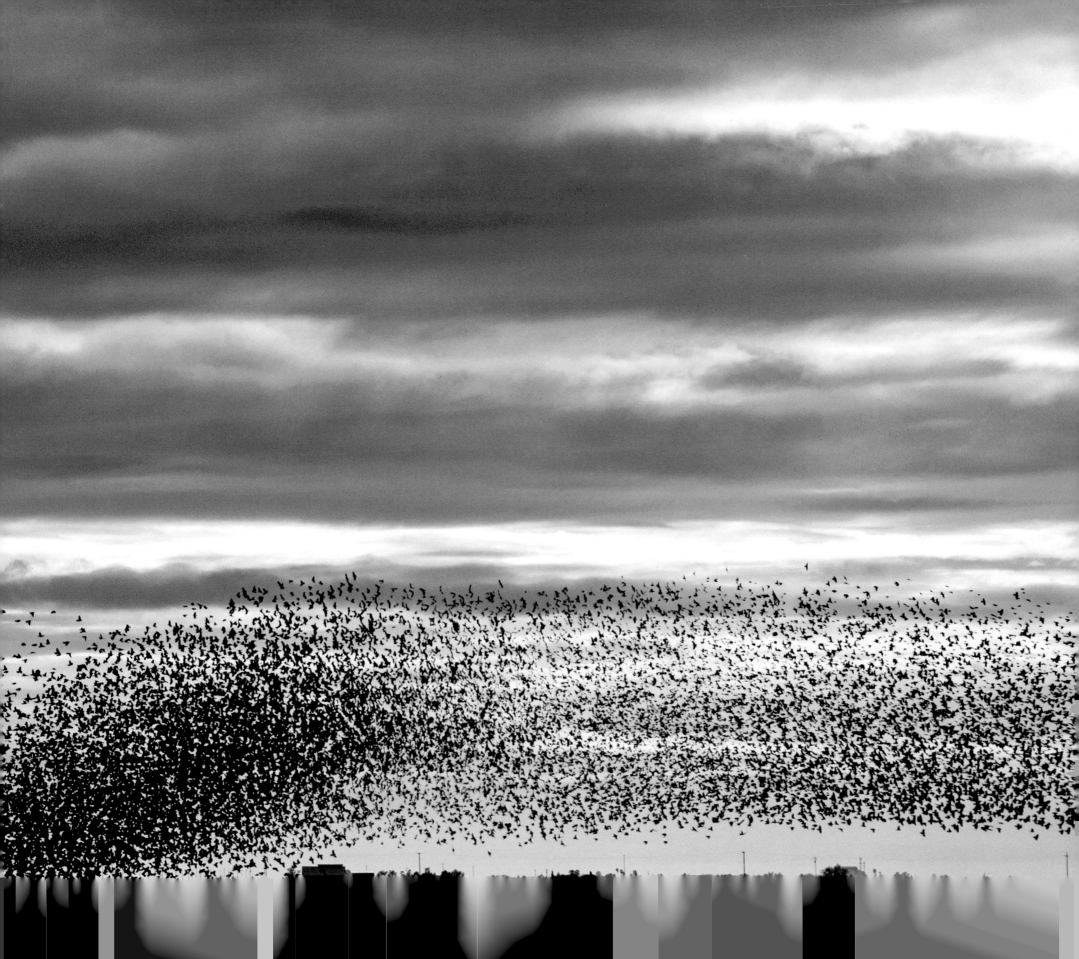

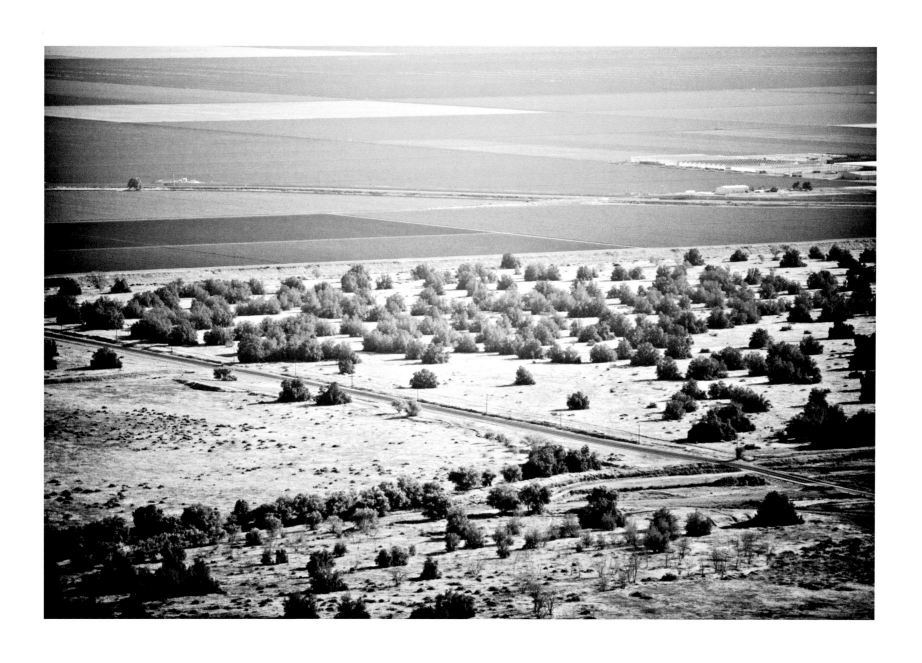

About the Photographs

Do people know or care where their food comes from? I initially became interested in the complex realities facing agriculture today during an *LA Times* assignment. Whether it's global competition, urban migration, or the environment, the landscape and people captured my imagination.

My curiosity led me across continents and cultures for a project called "Soil." It took me to Iceland, Turkey, Honduras, Peru, Spain, Japan, the United States, and Vietnam, where I could see firsthand the issues confronting farmers in today's culture.

When I first started *Westlands: A Water Story* years ago it had nothing to do with the current drought. Initially what got the news trucks and pundits out to the California Central Valley was what appeared to be a battle between farmers and a tiny fish, four fingers long. The farmer v. fish story arc is ideal and inflammatory for a news cycle, and then it gets buried under the next headline. The coverage demonized a defenseless fish or vilified farmers. I thought the story was far more complicated than that and deserved a longer

study. It was becoming clear that there are too many demands placed on an extraordinary resource.

California's Central Valley is one of the most productive food-growing regions in the world. Water policy, however, has left farming on the west side in danger of collapse. In dry years the west side is last in line for water allocations. Recent policy has cut their allocation even further. The result is fallowed land, workers moving out of town, farms collapsing, and businesses closing. The issue is much more complex than farmers v. environmentalists. It's about an antiquated water policy, a fragile ecosystem, and a growing population. *Westlands: A Water Story* is a series of images set against the backdrop of a pivotal period in the state's history.

It was a natural progression to turn my attention locally. I lived close to the Central Valley when I began *Westlands*. The landscape reminds me of the beautiful desert landscapes I loved when I lived in Arizona and New Mexico. There is an elusive quality to it like there is in the Southwest. Once I spent time there I couldn't stop going. The images of starling murmurations, willowy almond blossoms, and sun-drenched landscapes with abandoned almond orchards endure. The gravity of the place weighed on me. One gray December day in the Central Valley I drove hours from my home in San Jose with my husband to shoot video and stills of churchgoers as a way to show the culture and to humanize this politically charged region. It was one trip of many over the course of a few years. As we were driving back I couldn't believe what I saw. "Stop, pull over!!" My husband made a hard left and the

drama unfolded in front of us just a few feet away. The starlings were so close I needed to use a wide-angle lens to capture the breadth of the flock. The sound of thousands of birds moving through a fallow field in unison is something I'll never forget.

The farmers, shopkeepers, chefs, and migrant workers wove a story that is both complex and simple at the same time. This is a tight community whose existence depends on the availability of water. One of the first people I met was farmer Joe Del Bosque. Del Bosque's parents immigrated here from Mexico, and now he gets tapped to escort the president to witness the crisis that has befallen the west side. Joe is so passionate about the land, his crops, and the workers he employs. "Tough means uncertainties," he told me one sweltering summer day while sitting in a trailer at the edge of his farm. "We've been able to get through bad markets, bad weather, pests and diseases, government regulations. Nothing we have ever faced is tougher than losing our water," Joe said. "There's no way to overcome that."

Joe introduced me to the demanding life a farmer lives and also to the people who make up this community. I got to see firsthand what the land means to them. And I got to taste the most succulent cantaloupe straight out of the ground.

The majority of farmers tend family farms. Bill Koster and his brother have been maintaining a family farm for more than 130 years. Bill Koster gave me one of the more heartfelt interviews. He talked about the toll that the loss of water has taken on local families. "The people responsible for getting food on

the table are starving," he told me. "These are hardworking people with a lot of pride."

I interviewed the mayor of Mendota, who was wearing a green apron during his shift at a local supermarket. He talked about the ripple effect that the lack of water is having on communities. Without water, farm owners can't hire the workers who sustain the community by buying cars, groceries, housing, insurance, and more. "Some of the farmers are desperate," he told me. "The ripple effect just hits everybody. But it's all politics."

My many visits to farms on the west side of the Central Valley evolved into a portrait of a region. I'm drawn to the aesthetic of farming; there's a poetry to it. I can tell so many different stories with that as a vehicle. There is something sad about the disconnect between the urban and the rural. I encountered, and tried to capture, patterns of desolation, isolation, loneliness, and stark contrast. I wanted to illustrate these complex ideas and concepts in ways that are digestible and tangible and hopefully awe inspiring.

Acknowledgments

I want to express my deepest gratitude to Thomas Holyoke and Yiyun Li. Their contributions are brilliant. I have the utmost respect and admiration for Tom. He has encyclopedic knowledge on everything water. And I think Yiyun Li is a very important writer of this generation. Their belief in my project was one of the highlights of my career.

I also want to give a very special thanks to Joe Del Bosque. Without him I couldn't have made these images. I am indebted to him for his patience and his introductions.

And of course none of this would be possible without the help and support of my husband, Doug. His belief in me has always been unwavering, and for that I am eternally grateful.

Photographs

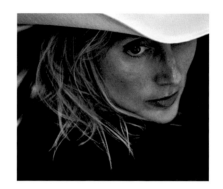

Contributors

Randi Lynn Beach came from Brooklyn, New York. She migrated west after receiving a BA from New York University. Along the way she lived in Albuquerque, Tucson, Denmark, and San Francisco, and she travels extensively to pursue projects she is passionate about.

An award-winning photojournalist, she has had her photography featured in everything from *Rolling Stone* to the *Washington Post*, *People*, and the *New York Times*. Her documentaries have been featured in *A Photo Editor*, *Lenscratch*, *Popular Photography*, and the *Huffington Post*, and they have been recognized by the Webby Awards. Most recently she finished *Westlands: A Water Story*, which was featured internationally in film festivals and recently won a Telly for Social Responsibility. Images from that series have been exhibited and published internationally.

Thomas Holyoke is a professor of political science at California State University, Fresno. He received his PhD from the George Washington

University and is a specialist in American politics. He teaches courses on Congress, interest groups and lobbying, and western water politics and policy. He is also the author of the books *The Ethical Lobbyist: Reforming Washington's Influence Industry*, *Interest Groups and Lobbying: Pursuing Political Interests in America*, and *Competitive Interests: Competition and Compromise in American Interest Group Politics*. He is also the author or coauthor of over thirty research articles on American politics published in some of the most prominent journals in political science. Currently he is working on an oral history project on water in the San Joaquin Valley for the Henry Madden Library at Fresno State.

Yiyun Li grew up in Beijing and came to the United States in 1996. Her debut collection of short stories, *A Thousand Years of Good Prayers*, won the Frank O'Connor International Short Story Award, the PEN/Hemingway Award, the Guardian First Book Award, and the California Book Award for first fiction. Her novel, *The Vagrants*, won the gold medal of California Book Award for fiction and was short-listed for the Dublin IMPAC Award. *Gold Boy, Emerald Girl*, her second short-story collection, was a finalist for the Story Prize and was short-listed for the Frank O'Connor International Short Story Award. *Kinder Than Solitude*, her latest novel, was published to critical acclaim. Her books have been translated into more than twenty languages.

Yiyun Li has received numerous awards, including the Whiting Award, a Lannan Foundation Residency fellowship, a 2010 MacArthur Foundation

fellowship, and the 2014 Benjamin H. Danks Award from the American Academy of Arts and Letters, among others. She was selected by *Granta* as one of the twenty-one Best of Young American Novelists, and she was named by the *New Yorker* as one of the top twenty writers under forty. She is a contributing editor to the Brooklyn-based literary magazine, *A Public Space*.